IMAGES
of America

MORRIS-JUMEL
MANSION

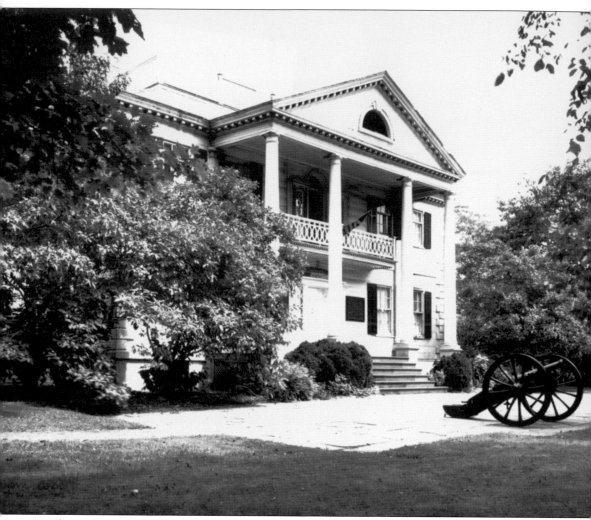

The Morris-Jumel Mansion has been a witness to history throughout its existence. The house is not only the oldest surviving residence in Manhattan; it is the only surviving headquarters of George Washington as well. This photograph encapsulates many of the most important facets of the mansion: its Neoclassical facade, its existence during the American Revolution, and its location's high elevation, which made the house a perfect summer estate. (Courtesy of the Morris-Jumel Mansion.)

ON THE COVER: One of largest and grandest celebrations the Morris-Jumel Mansion has seen in its history was its rededication as a museum on George Washington's birthday in February 1907. Moses Herrman, commissioner of parks from January 1, 1906, to September 1907, is pictured in the center of the group. The era of Colonial revivalism emphasized patriotism and national pride, and the Daughters of the American Revolution (DAR) adopted the mansion as a symbol. The date above the balcony, 1758, indicates the year when early historians thought the house was built. (Courtesy of the Morris-Jumel Mansion.)

IMAGES
of America

MORRIS-JUMEL MANSION

Carol S. Ward

ARCADIA
PUBLISHING

Copyright © 2015 by Carol S. Ward
ISBN 978-1-4671-2343-3

Published by Arcadia Publishing
Charleston, South Carolina

Printed in the United States of America

Library of Congress Control Number: 2014954868

For all general information, please contact Arcadia Publishing:
Telephone 843-853-2070
Fax 843-853-0044
E-mail sales@arcadiapublishing.com
For customer service and orders:
Toll-Free 1-888-313-2665

Visit us on the Internet at www.arcadiapublishing.com

*To Marion L. Ward, for a lifetime of encouragement
and inspiration. In memory of Jack J. Ward.*

CONTENTS

ACKNOWLEDGMENTS

The Morris-Jumel Mansion is a museum that exists thanks to the small, yet immensely dedicated, group of people who love it like their own home. The staff, consisting of Naiomy Rodriguez, Jasmine Helm, Christopher Davalos, Danielle Hodes, Mark DeLucas, Trish Mayo, and Emilie Gruchow, provides the support that allows the mansion to run and thrive. In addition, volunteers and docents, with hundreds of hours of service and decades of experience among them, assist in bringing the story of Morris-Jumel to life. Lastly, the board of trustees is made up of ambassadors and stewards of the historical site.

I wish to thank my family, specifically my mother Marion L. Ward and my aunt Rita G. Buckholtz for always being strong female role models. Also, thank you to the late Prof. Tom Somma from the University of Mary Washington, who helped start me on my path to becoming a museum educator and encouraged me to think outside the box. My best friend, Dr. Allison Stagg, is a constant support both personally and professionally. Lastly, thank you to my *mejor amigo*, Lino Figueroa, for always being there for me.

Unless otherwise noted, all images are courtesy of the Morris-Jumel Mansion.

INTRODUCTION

The Morris-Jumel Mansion has truly been a witness to history. Known throughout history by many names, such as Mount Morris, the Jumel Mansion, and "the Jewel of Sugar Hill," the house has seen 250 years of change as Upper Manhattan shifted from rural farmland, Harlem Heights, and now the diverse and dynamic community of Washington Heights.

The house was built 11 years before the American Revolution, in 1765, by British colonel Roger Morris and his American wife, Mary Philipse. The breezy hilltop location proved ideal for the family's summer home. Known as Mount Morris, this northern Manhattan estate stretched from the Harlem to the Hudson Rivers and covered more than 130 acres. The vast farmland included various outbuildings and a dock on the East River. Records indicate the presence of slaves working the land and inside the manor house. The mansion is built in the Palladian style, and the two-story octagon at the rear of the house is believed to be the first of its kind anywhere in the colonies. Roger Morris's father, an architect, designed Marble Hill House in London. Although the architect of Morris-Jumel is unknown, the belief is that Roger Morris assisted in the design.

Due to their loyalty to the crown, the Morrises were eventually forced to return to England. During the war, the hilltop location was valued for more than its cool summer breezes. With views of the Harlem River, the Bronx, and Long Island Sound to the east, New York City and the harbor to the south, and the Hudson River and Jersey Palisades to the west, Mount Morris proved to be a strategic military headquarters. Gen. George Washington selected the mansion as his headquarters in the fall of 1776, and he fought the Battle of Harlem Heights on September 16. Shortly after, Washington and his troops left the mansion; for a time, it was occupied by British and Hessian forces.

President Washington returned to the mansion on July 10, 1790, and dined with members of his cabinet. Guests at the table included two future US presidents: Vice Pres. John Adams and Secretary of State Thomas Jefferson. Secretary of the Treasury Alexander Hamilton and Secretary of War Henry Knox also attended. The mansion became the site for some of the first cabinet meetings of the new government. The dinners were anything but peaceful, as the varying political ideas of the Founding Fathers were discussed.

Serving as an inn for New York City–bound travelers, the house passed through many hands. Finally, in 1810, the mansion was restored to its original purpose as a country house by the French emigrant Stephen Jumel and his wife, Eliza. Stephen and Eliza added new doorways and stained glass to the facade. Regular visitors to France, they furnished much of the house in the French Empire style. Many of those objects, including a bed said to have belonged to the Emperor Napoleon, remain in the mansion today.

Stephen Jumel died in 1832, and Eliza, then one of the wealthiest women in New York, later married former US vice president Aaron Burr. Their marriage lasted just two years. Eliza retained ownership of the mansion until her death in 1865. After a 20-year court battle, which was finally settled by the US Supreme Court, the property was divided and sold.

The mansion itself survived the subdivision along with a small plot of land. In 1894, it was purchased by Gen. Ferdinand P. and Lillie Earle. In tune with the deep patriotic sentiment of the late 19th century, the Earles revered Washington and the mansion's history as his headquarters. They persuaded the City of New York to purchase the house and remaining property in 1903 and to preserve it as a monument to the nation's past. In 1904, the Washington's Headquarters Association, formed by four chapters of the Daughters of the American Revolution, took on the task of operating the museum.

The 20th century was an era of change for the mansion, as Washington Heights became more urbanized and the demographics of the neighborhood changed from Jewish to African American to Latino. During the Harlem Renaissance, Duke Ellington said that the mansion was "the Jewel of the Crown of Sugar Hill," and the house saw such legends as Dizzy Gillespie and Lena Horne walk its halls and live directly across the street.

Today, the Morris-Jumel Mansion is an educational institution where 22,000 visitors a year tour the period rooms that cover the history of the mansion. Each year, more than 9,000 school students arrive to learn about Colonial life, the Revolutionary War, and the colorful inhabitants. The mansion offers a wide range of family and adult programs, all rooted in the dynamic history of the house, while also engaging the local community with contemporary art installations and theater performances. The mansion serves not only as a lasting reminder of New York history through the ages, but also as a vital community resource for Upper Manhattan. The rich, diverse, and dynamic neighborhood of Washington Heights is literally outside the mansion's gate, and the museum strives to make connections and partnerships with other arts and cultural institutions to expand its educational scope each year.

Both a New York City and a national landmark, Morris-Jumel Mansion is owned by the New York City Department of Parks & Recreation, operated by Morris-Jumel Mansion, Inc., and is a member of the Historic House Trust of New York City. Through architecture and a diverse collection of decorative arts objects, each room of the Morris-Jumel Mansion reveals a specific aspect of its colorful history from the 18th to the 19th centuries. Looking to the future, and the 250th anniversary, of "the Jewel of Sugar Hill," as paraphrased from Duke Ellington's description of the Morris-Jumel Mansion, the hope is to not only preserve the house and its collections for future generations, but also to encourage visitors to make their own historical connection each time they visit.

One

A COUNTRY HOUSE
IN THE HEIGHTS
18TH-CENTURY SPLENDOR

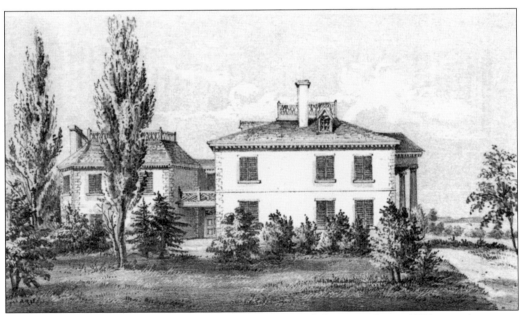

This print, *Col. Roger Morris House. Washington's Head Quarters, Sept., 1776; now known as Madame Jumel's Res.*, is from D.T. Valentine's Manual, dating to 1854. The image shows the west side of the mansion, with the exterior shutters closed and a road in front of house. It gives the viewer a sense of the placement of the house on the original 1765 plot of land.

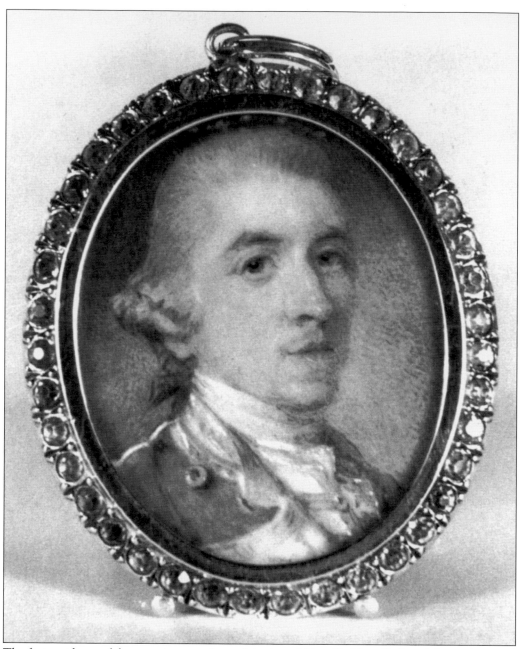

The first residents of the mansion were Roger Morris and his wife, Mary Philipse Morris. A retired British colonel, Roger Morris fought alongside George Washington in the French and Indian War and stayed on in the colonies after retiring from service. Roger Morris's father, an architect in England, was instrumental in designing Marble Hill House in London. Although the architect of Mount Morris remains unknown, the belief is that Roger assisted in its design. This framed miniature portrait of Roger Morris is a copy by his great-great-granddaughter, Marjorie Beverly Sanders, from an original miniature owned by his descendent Joanna (Morris) White.

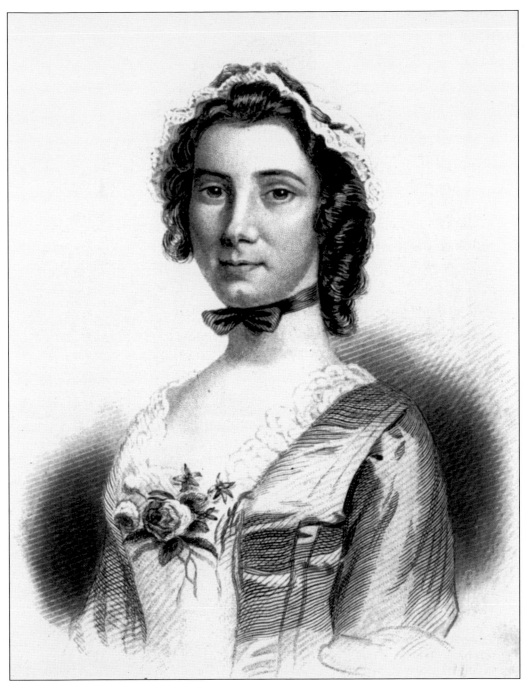

Mary Philipse, the daughter of wealthy Dutch merchants, resided in Tarrytown, New York, for most of her childhood. An heiress, she and Roger became one of the wealthiest couples in the colony of New York, and the mansion became a symbol of British colonial power and prestige. It was Mary who returned to the mansion during the Revolutionary War to gather the family's possessions and make the arduous journey back to England. The engraving of Mary Philipse, by H.B. Hall from an oil painting by John Wollaston, dates to 1758.

The mansion originally known as Mount Morris is situated on the second-highest natural landmass in Manhattan. Roger Morris selected the location in Upper Manhattan for its distance from the crowded, and disease-ridden, lower areas of New York City proper. His summer country estate incorporated 130 acres of land, including farmland, orchards, gardens, outbuildings for the family's slaves, and the house itself. Morris had builders blast the hill away with kegs of gunpowder

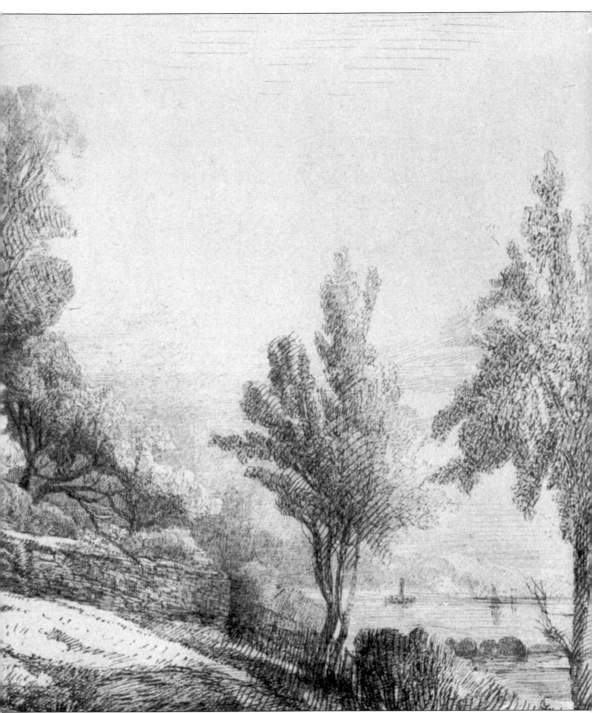

to ensure the perfect location, with views of both the Harlem and Hudson Rivers. The height allowed for summer breezes to cool the home on hot August days. This print, *View of the Jet at Harlem River*, dates to 1842 and is one of a series of plates in the series "Illustrations of the Croton Aqueduct" by F.B. Tower.

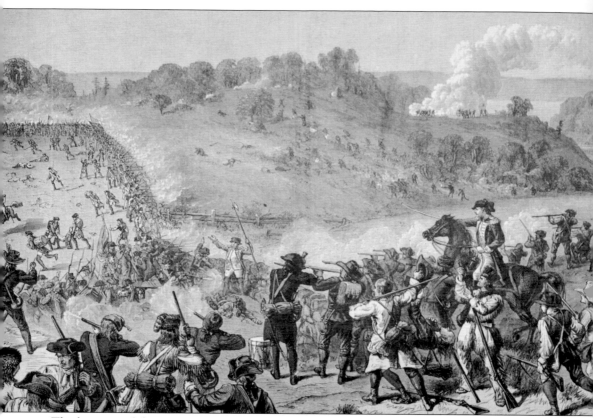

The location of the mansion was not only appreciated by the residents for pleasure. During the American Revolution, George Washington selected the mansion for a strategic reason. He knew he could use the high elevation of the structure to his advantage after being forced to retreat during the Battle of Brooklyn. The Battle of Harlem Heights took place in the environs of the mansion on September 16, 1776. Washington was able to see five miles south to New York Harbor, both the Harlem and Hudson Rivers, as well as into New Jersey and Connecticut. Unfortunately for Washington, the short-term victory did not give him a reprieve, as the British returned with reinforcements. He then fled to White Plains, not returning to New York City until the end of the war.

Two

The Jumel Era
Opulence of the 19th Century

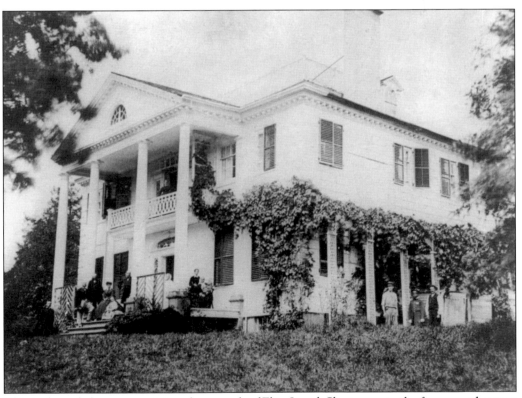

This is the only known surviving photograph of Eliza Jumel. She is seen in the foreground corner of the front porch, at approximately age 85, surrounded by the Chase family and holding her great-grandchild. The photograph shows elements of the house, such as the exterior shutters and the side trellises, which no longer exist.

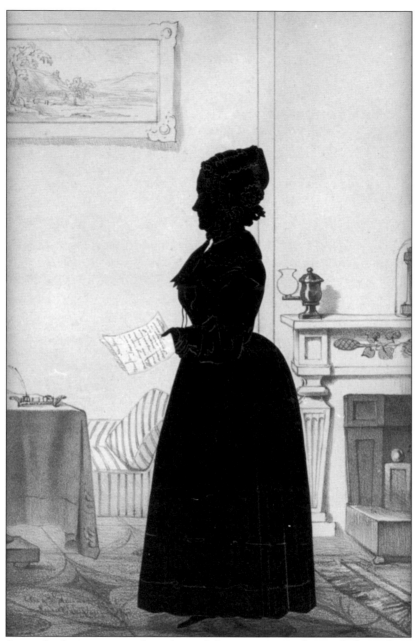

Eliza Jumel was the longest-tenured resident of the mansion, and some believe she still resides there. She began life as Betsey Bowen, and her origins are clouded in myth and historical fiction. Records indicate she moved to New York as a young woman and became an actress, and perhaps a courtesan to wealthy and influential men of the day. Her marriage to wine and dry-goods merchant Stephen Jumel secured her position in respectable high society. Over the course of their 20-year marriage, she assisted him in tripling his fortune. Stephen and Eliza purchased the mansion in 1810 as their summer country estate. Eliza focused on decorating her home in the height of the French Empire style, importing furniture from France and adding decorative stained-glass windows. This is a silhouette and lithograph portrait of Madame Jumel in Saratoga, New York, by Auguste Edouart.

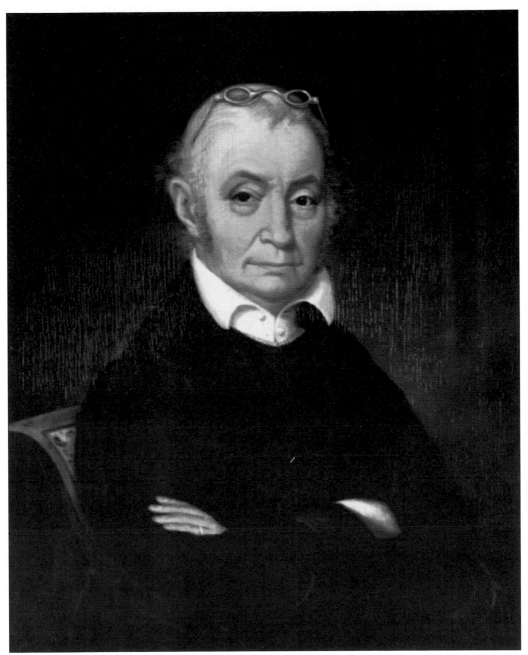

Upon Stephen Jumel's death, Eliza was one of the wealthiest widows in New York. However, she sought additional security in terms of her place in society. Her marriage to former vice president Aaron Burr in 1833 bolstered her footing among the New York elite. The marriage was solely one of convenience for both sides. Aaron Burr was 77 when they married, and he was looking for a source of funds to assist him to cover his expenses. Eliza quickly saw his endgame and also learned of his infidelity with a much younger woman. Eliza sued for divorce. In an interesting turn of events, her lawyer was Alexander Hamilton's son. Perhaps this was delayed karma for Aaron Burr, who had shot and killed Hamilton 30 years prior. The divorce was finalized in 1836, on the same day that Burr died. This portrait by James Van Dyck is dated to 1834.

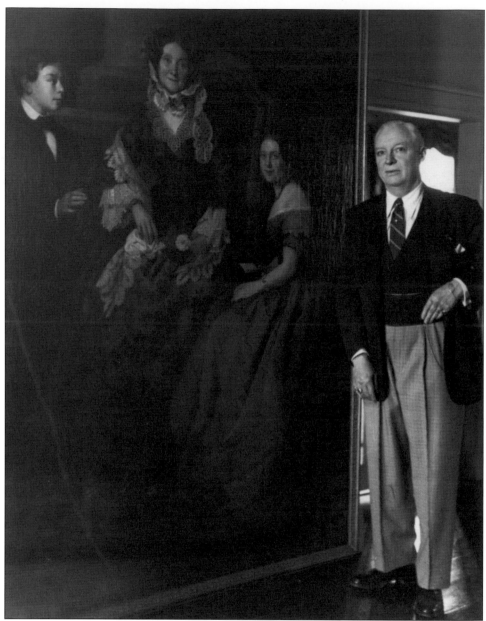

This iconic portrait of Eliza Jumel with her grandchildren has always held pride of place at the mansion. Madame Jumel and her grandchildren Eliza Jumel Chase and William Inglis Chase sat for this portrait while on a grand tour in Europe. A monumental journey to undertake at nearly 80 years old, Madame Jumel took her grandchildren to Italy, France, and England. While the family was in Europe, the younger Eliza, 17, was presented at the court of Louis Philippe in France. In France, she married Paul Guillaume Raymond Pery, a young Frenchman, and the couple visited the mansion in 1865 and later settled in New York. Photographic documentation from the 19th century reveals that this large portrait originally hung in the front hall of the mansion and was then moved to the Octagonal Drawing Room. The portrait was moved to the second floor in the 1940s. The portrait is by Alcide Ercole and dates to 1854. Here, curator Henry DeFries standing by the portrait.

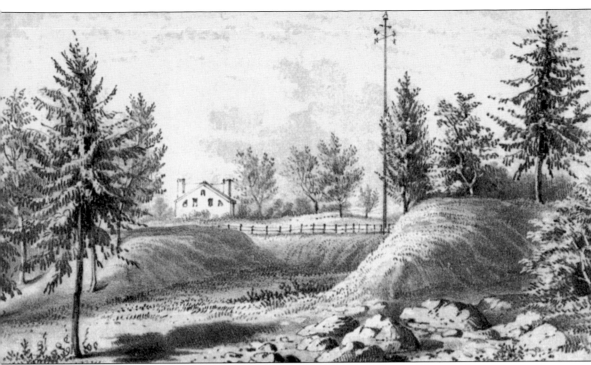

The land surrounding the estate during the Jumel era expanded to 138 acres. Eliza was less concerned about the land itself than the house, but she still incorporated areas of ornamental gardens, orchards, and wild wooded sections. The mansion was still considered to be in the countryside for the majority of Eliza's tenure there, and she and Stephen used it as their "country seat" to lavishly entertain the upper levels of New York society. After Eliza's death, her granddaughter oversaw the house and the property. Due to a 20-year court battle for control of the estate, she was forced to sell off the majority of the land and many of Eliza's possessions, including decorative art, furnishings, and paintings. The house would never again be the lavish manor it had been during the Morris and Jumel eras.

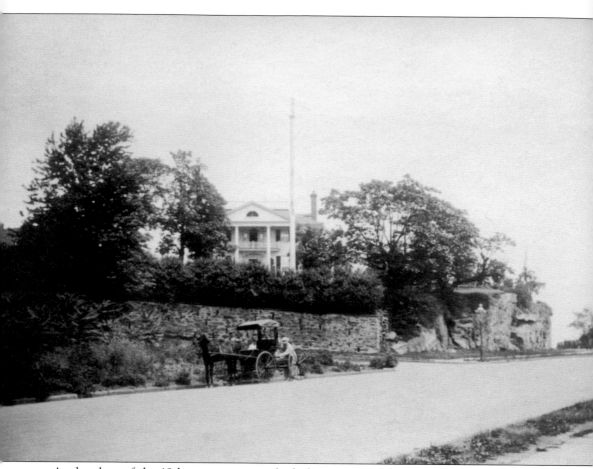

As the close of the 19th century approached, the concept of the landed gentry and large-scale summer country estates came to an end. The sale of the land surrounding the mansion signaled the encroachment of Upper Manhattan populations and the progress of industrialization in the neighborhood. The mansion would always hold its place on top of "Mount Morris," but photographs from the late 19th century show a very dramatic change in the landscape. The mansion is seen here from the bottom of Edgecombe Avenue. The horses and carriages give a sense of isolation that would become a thing of the past in the ensuing 10 years, as the mansion shifted from a private home to a museum.

Three

THE LATE 19TH CENTURY
A CHANGING LANDSCAPE

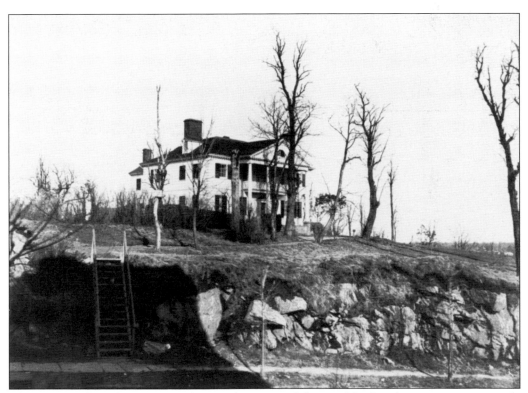

The terrain of Washington Heights, as the name of the neighborhood suggests, is extremely hilly, rocky, and steep. This is evident here, as the staircase winds its way up Edgecombe Avenue and 160th Street to arrive at the mansion. The landscape also shows the barren nature of the grounds in the late 19th century, prior to the L'Prince and Earle families making the mansion their home.

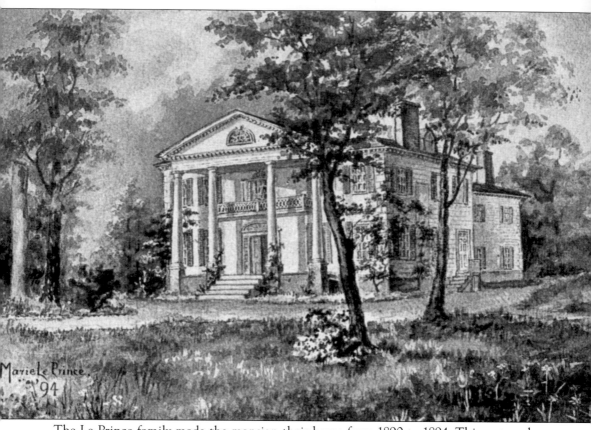

The Le Prince family made the mansion their home from 1890 to 1894. This watercolor was painted by Gabriella Marie Le Prince, the daughter of the family, just before they vacated. It shows the well-kept house surrounded by natural wilderness. The original shutters are still present, and the side kitchen area was not yet built. All of the Le Prince family members were artistic; the father, Augustin Le Prince, was one of the earliest photographers and filmmakers in the early 20th century.

Gabriella's mother, Elizabeth Le Prince, taught at the Washington Heights School for the Deaf, located a few blocks from the mansion on 160th Street and Broadway. Her father, Augustin Le Prince, seen in these images, was a photographer and an inventor. He applied for a US patent in November 1886 for a very early version of a motion-picture camera. Unfortunately, even though his request was granted in 1888, a clerical error made it impossible for him to challenge Thomas Edison's patents of the same time. In 1889, Augustin sent his family to live in New York, and the mansion became their home. He stayed in Paris to continue work on his motion pictures. Historical records indicate that his brother placed him on a train in Dijon on September 16, 1890; after that, Augustin disappeared and was never seen again. The family left the mansion in 1894, as it was being sold to another owner.

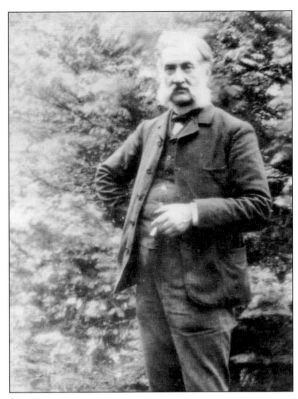

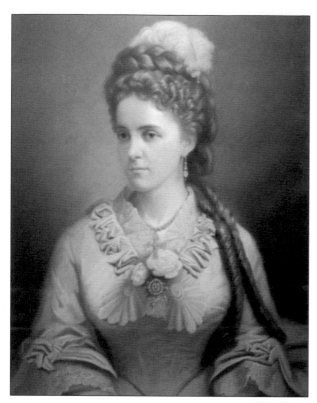

Lillie J. Earle (left) and her husband, Gen. Ferdinand Earle (below), acquired the mansion in mid-1894. Earle claimed to be a descent of Capt. William Morris, a close relative of Roger Morris. The mansion then became known as Earle Cliff. Although they took great pride in the property, the Earles were unable to maintain it in its current state. The family as a whole introduced many changes to the mansion, but they also took interest in its historical significance. When General Earle died in 1903, he was survived by his widow and four sons. The Earles were the last private family to live at the mansion. Interestingly, Lillie founded the Washington Heights chapter of the Daughters of the American Revolution (DAR), which would later take charge of the mansion. (Both, courtesy of Chantal E. Rosset Hyde.)

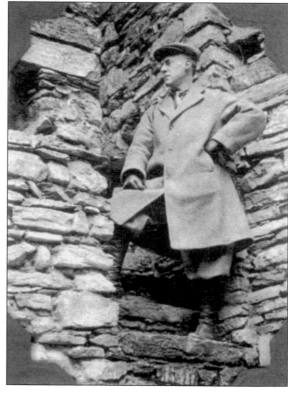

The photograph on the right demonstrates one of the major changes the Earle family made to the physical infrastructure of the mansion. They completely changed the Octagon to create a two-story studio, with a skylight, for one of their sons, who was a painter. They broke into the garret on the right to create the north light, a dormer window was removed, and a railing with an English hob-gate was brought up from the parlor to decorate the studio itself. It was believed that a fire had already damaged part of the octagonal structure and that this studio served the purpose of renovating the space while also making it useful for the Earle son, Ferdinand Pinny Earle (below).

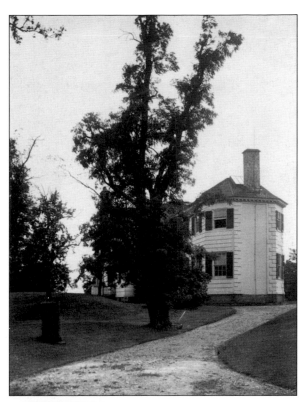

Washington Headquarters, 1776.

FOR SALE.

A large plot of ground known as the JUMEL PROPERTY, on Washington Heights. This property consisting of nearly twenty-seven (27) CITY LOTS, is bounded by West 160th and 162d Streets, Jumel Terrace and the new Edgecombe Avenue, overlooking the entrance to the new SPEEDWAY and VIADUCT, and running parallel with the HIGH BRIDGE PARK. This property is on the HIGHEST part of Manhattan Island, and has an unobstructed view of the CITY, LONG ISLAND and the SURROUNDING COUNTRY. This plot is now occupied by the old historic mansion, built in 1758 by Col. Roger Morris (known as the MORRIS HOUSE during the Revolutionary War, and as Washington's Headquarters), afterward as the JUMEL MANSION, now known as EARLE CLIFF. When sold this mansion will be moved to part of the old property on the opposite side of Edgecombe Avenue. This valuable plot of twenty-seven city lots would make one of the grandest spots in the city for a MAGNIFICENT RESIDENCE, as it is now laid out for that purpose, with lawns, trees, shrubs, etc., or it could be cut ADVANTAGEOUSLY INTO BUILDING LOTS, or for a FIRST-CLASS APARTMENT HOUSE HOTEL, covering the ENTIRE PLOT. This property can only be appreciated by visiting the ground on a clear day.

For futher particulars, address

offered for sale
1898.

FERDINAND P. EARLE,

EARLE CLIFF,
WASHINGTON HEIGHTS,
CITY.

In 1898, Ferdinand Earle advertised the property for sale, and the plan was to move the mansion across Edgecombe Avenue. Luckily, no buyer stepped forward. As this advertisement mentions, potential buyers could have turned Earle Cliff into "building lots" or a "first-class apartment house hotel," covering the whole area. During the Earles' ownership, the estate shrank from 37 acres to the city block it constitutes today.

Four

THE 20TH CENTURY
COLONIAL REVIVALISM

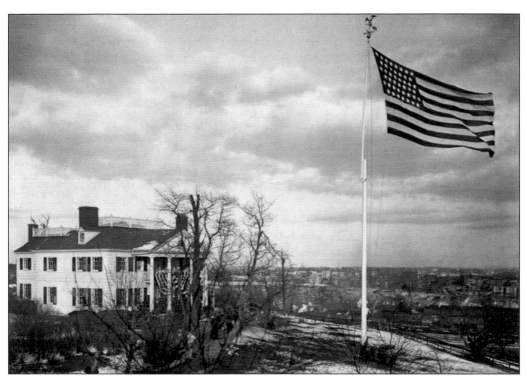

This photograph of the mansion illustrates the strong patriotism present during the early 20th century, as the house transitioned into a museum. Shown here are the south and east sides of the house during an early celebration of George Washington's birthday. A flag is draped over the second-floor balcony, and many people are in front of the house.

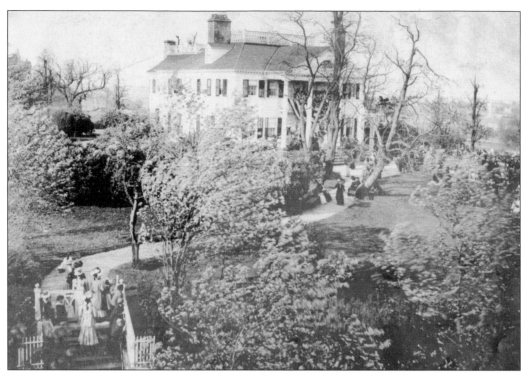

The grand reopening of the mansion in 1907 was, and still is, one of the largest events in its history. This photograph of the mansion demonstrates the natural style of the grounds. Seen here are the front steps at the southwest corner of the property, with a crowd of ladies and children.

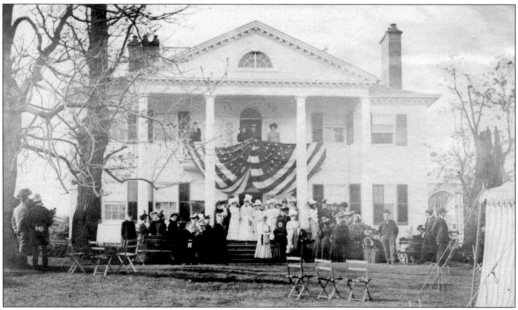

Lillie Earle was instrumental in getting the Daughters of the American Revolution interested in becoming involved in the upkeep and interpretation of the mansion. The Washington's Headquarters Association was made up of four chapters of the DAR. The group officially took control of the mansion and held a formal opening of the house as a museum in May 1907.

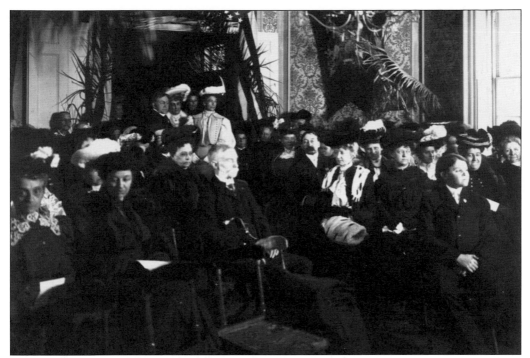

The Octagon Room was packed with visitors in their finest dress, celebrating the opening of the mansion as a historic house. The mansion held the distinction of being the only surviving Washington's headquarters in Manhattan. Patriotic fervor was high at the dawn of the 20th century.

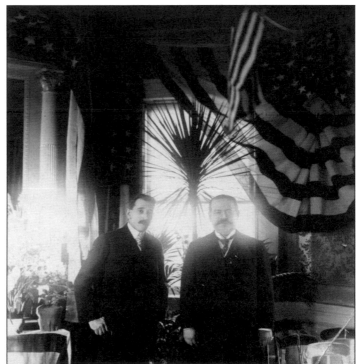

The event was an opportunity for local dignitaries, New York City politicians, and the public to come together in support of the mansion. Standing at right is Moses Herrman, the commissioner of the New York City Parks Department at the time.

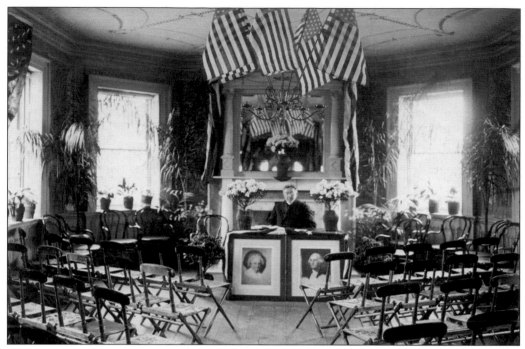

The date of this photograph is unknown. Shown here is Commissioner of Parks John Pallas, who served prior to Moses Herman, so this scene may date to the ceremony transferring the house to the parks department on December 28, 1903. The Adamesque ceiling installed by the Earles is clearly shown.

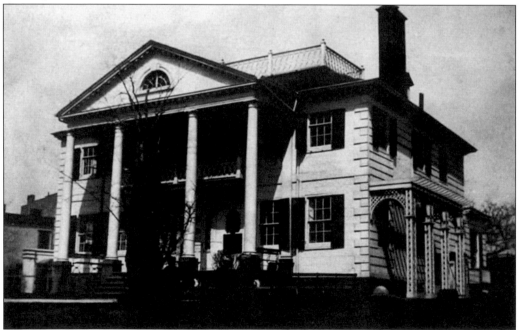

The mansion was now one of the symbols not only of the long history of New York City, but also of the historic house model for the early 20th century. The DAR wanted the house to showcase American history through the lens of the American Revolution and George Washington.

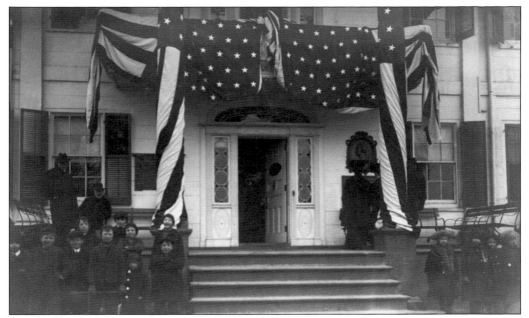

George Washington's birthday continued to be the main event at the mansion into the 1910s. This celebration, very similar in style to the one in 1907, showcased patriotic bunting, flags, and New York City schoolchildren. Note the plaque to the right of the main door with Washington's profile; this, as well as the original "Washington's Headquarters" signage, are still in the museum's collection today.

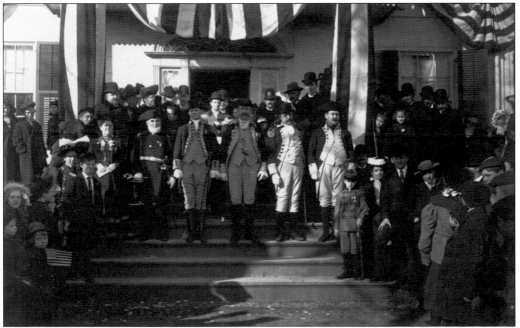

A huge draw, the George Washington celebration always included historically dressed reenactors of Washington and his troops. They would enter to begin the festivities and interact with the crowds throughout the day. As the Battle of Harlem Heights was considered the first victory in the American Revolution, the patriotism was constantly played up to encourage spectators.

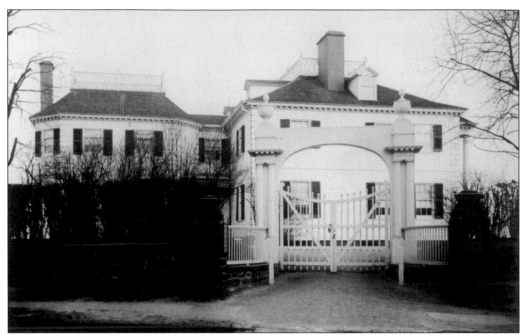

In 1912, a new gate and entrance were created for the mansion, with guests now coming through the Jumel Terrace side. This gate, which remained in place until 1957, was conceived as a reproduction of the entryway that would have been present during the Jumel era, with stone pillars topped with urns.

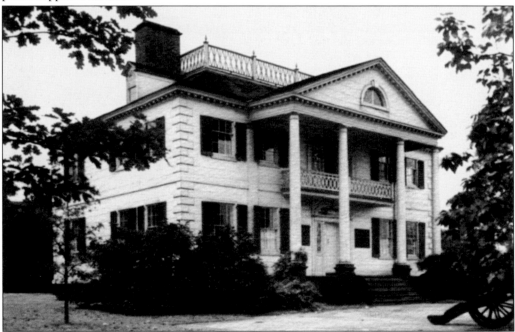

The four chapters of the DAR were acting entirely independently when the mansion became a museum. At the time, each room featured a completely different interpretive style. The DAR agreed that it needed to hire a curator/director to oversee the interpretive plan and bring a heightened level of museum practices to the house.

Throughout the 20th century, the exterior main entrance of the mansion was flanked by two cannons. The cannons stood guard outside the museum and were a clear indication of the era being emphasized inside the house. The pieces were eventually donated to the Museum of the City of New York.

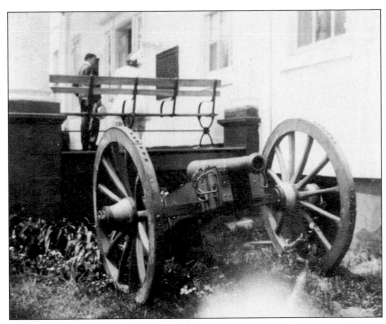

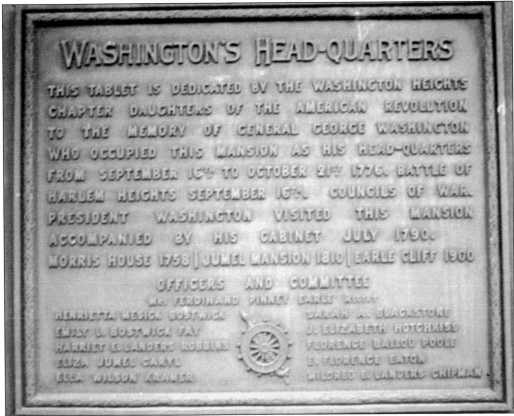

WASHINGTON'S HEAD-QUARTERS

THIS TABLET IS DEDICATED BY THE WASHINGTON HEIGHTS CHAPTER DAUGHTERS OF THE AMERICAN REVOLUTION TO THE MEMORY OF GENERAL GEORGE WASHINGTON WHO OCCUPIED THIS MANSION AS HIS HEAD-QUARTERS FROM SEPTEMBER 15th TO OCTOBER 21st 1776. BATTLE OF HARLEM HEIGHTS SEPTEMBER 16th. COUNCILS OF WAR. PRESIDENT WASHINGTON VISITED THIS MANSION ACCOMPANIED BY HIS CABINET JULY 1790. MORRIS HOUSE 1758 | JUMEL MANSION 1810 | EARLE CLIFF 1900

OFFICERS AND COMMITTEE

Mrs. FERDINAND PINNEY EARLE Regent

HENRIETTA WESTON BOSTWICK
EMILY L. BOSTWICK FAY
HARRIET SANDERS ROBBINS
ELIZA JUMEL CARYL
ELLA WILSON KRAMER

SARAH A. BLACKSTONE
J. ELIZABETH HOTCHKISS
FLORENCE BALLOU POOLE
E. FLORENCE EATON
MILDRED SANDERS CHIPMAN

A large bronze sign describing the house was placed to the right of the front door. The Washington headquarters sign would remain there for the majority of the 20th century. Note the incorrect date for the building of the mansion, originally thought to be constructed in 1758.

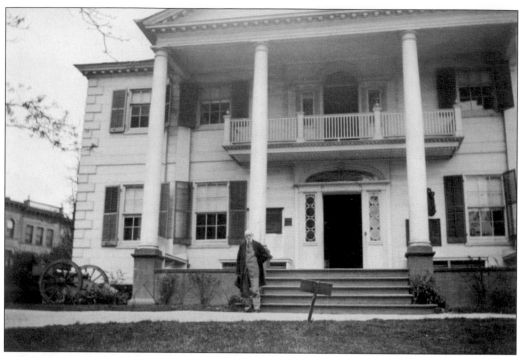

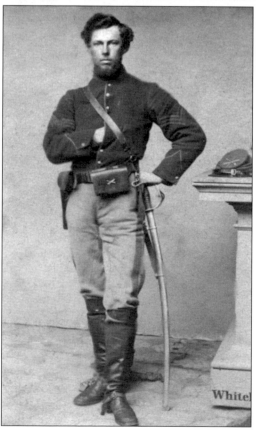

White[

Above, curator William Henry Shelton stands in front of the Morris-Jumel Mansion. Shelton, born in 1840, was named curator in 1908. He took on the position at an age when most people were thinking about retirement. Instead of going to college, he had joined a New York artillery regiment during the Civil War (left). Captured during the Battle of the Wilderness, he escaped four times. After the war, Shelton became an author and artist, working at the mansion until 1925. A confirmed bachelor, he died in 1932. Shelton worked extensively on researching the history of the mansion and published the foremost history of it in 1916. He was instrumental in persuading the city to appoint a committee to assist with the restoration of the house itself. Shelton envisioned a more holistic approach to the interpretation of the rooms, each focusing on a different time period in the history of the mansion, a style that was ahead of its time.

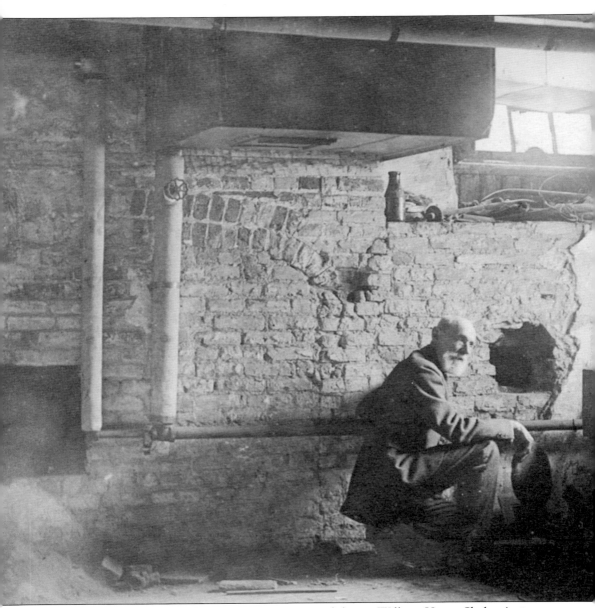

Although the downstairs kitchen area was not restored during William Henry Shelton's time, guests could bravely walk through a hole he and Reginald H. Bolton, a respected amateur archeologist, cut into the wall to view the old fireplace. Shelton mainly achieved his goal of an interpretive style, although duplication of items often frustrated him. Around the time of World War I, he officially changed the name of the museum to Washington's Headquarters and had all the rooms, even the old garret, opened to the public. He consolidated the collection by having a large public auction in 1916; unfortunately, this also meant that a number of original artifacts left the mansion. There was constant conversation, and debate, between Shelton and the various chapters of the DAR about the collection and the interpretations of the rooms. This time period arguably offered the most diverse range of items on display, however little some of them had to do with the actual history of the mansion.

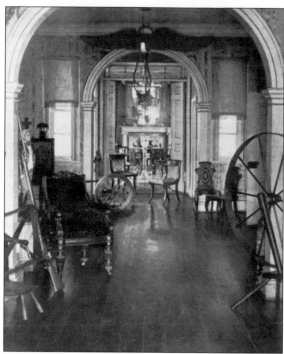

The various chapters of the DAR collected as they saw fit, and it was up to Shelton to curtail their desire to acquire more artifacts than the mansion could hold or to acquire multiple copies of items. Shelton is quoted as saying, "We have already six flax wheels, and it would be an act of mercy to stop the supply." These spinning wheels, prominent in this photograph, are, for the most part, still in the museum's collection.

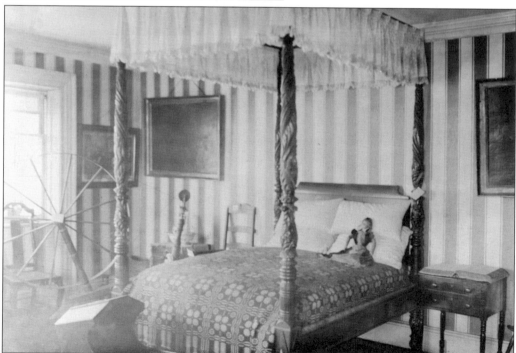

Flax wheels, such as the one seen here in Eliza Jumel's bedchamber in the early days of the museum's life, would, in reality, never have been found in such a location. The grand nature of her bedroom, which would come about after later interpretations, was dismissed for a simpler, homespun look. The baby's bed and dolls were also flights of fancy on the part of the DAR and not correct for the time period being represented.

This photograph of the dining room has clearly recognizable items from Eliza Jumel's inventory, specifically, the cane-bottomed chairs, sideboard, and shield-back chair. The stove, which survived the updates to the rooms, is clearly late 19th century. This late-Victorian theme is what Shelton was fighting against as he sought to create a more cohesive historical story.

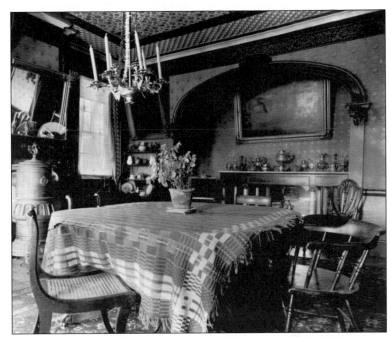

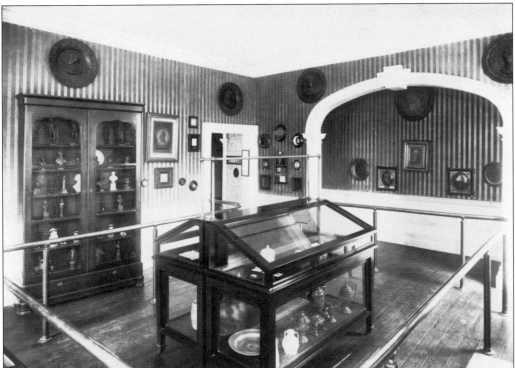

William Henry Shelton transformed the dining room from a scene of Victorian bric-a-brac to the organized display shown here. He emphasized order, associated with the Washington era, and relied on portrait busts and smaller items in glazed cases to tell the story. This room was arranged in part with Reginald Pelham Bolton, and the military memorabilia were said to be Shelton's favorite display in the museum.

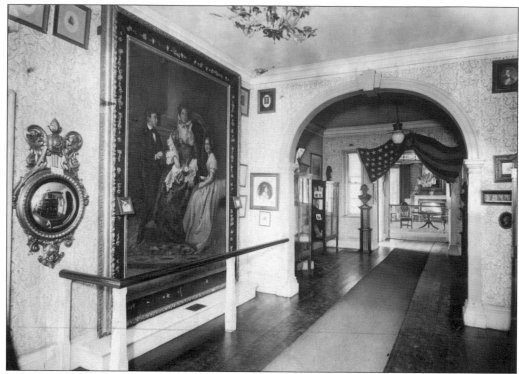

The first-floor hall, seen here around 1920, is dominated by the large-scale portrait of Eliza Jumel and her grandchildren. Shelton's main interpretive method was to display prints of the important historical figures related to the mansion. To the right of the portrait is a drawing of a young Eliza Jumel in profile.

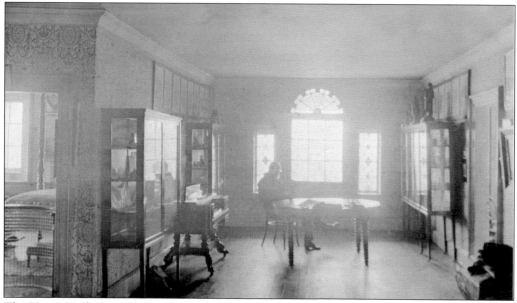

The Upper Hall, shown here in the Shelton era, includes several display cases. Shelton is at the table reading a book. The mansion became his home away from home, and he believed in making it a model for historic preservation and historic houses at the time.

Shelton embraced the grounds and park as part of the experience of the mansion. As part of the New York City Parks Department, the house enjoyed a good relationship with the neighborhood, as residents saw Roger Morris Park as an extension of their backyards.

Residents enjoy Roger Morris Park on a summer day. The population of Upper Manhattan at the end of the 19th century consisted mainly of upper-class landed gentry, but the shift was slowly turning to working-class families and immigrants coming uptown for a more affordable area and more space to live.

Kady Brownell was the caretaker of Morris-Jumel Mansion from 1903 to 1913. The tradition of having a caretaker for the house and its grounds continues today. However, caretakers today do not house a pet pony in the park.

This exterior photograph, taken from the southeast, shows some of the additions the Earles made to the mansion and that survived through the first phase of the house becoming a museum. Among the changes are, in particular, the one-story kitchen addition (right, rear) and the plumbing stack emerging from the northeast room.

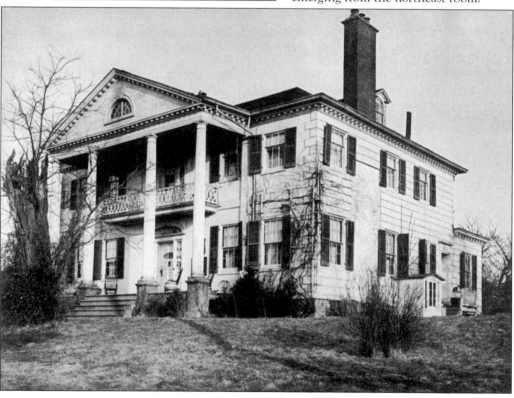

The porch of the mansion always served as the focal point of people's visits and as a setting for photographs. Here, three women, identified as Elizabeth Brown (left), Bessie Schell (center), and Virginia Place, sit on the front steps on a beautiful summer day.

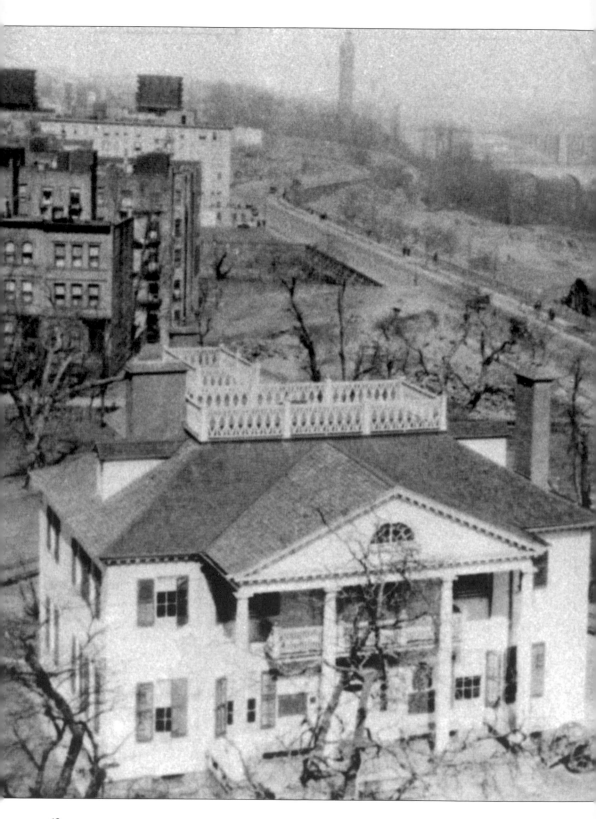

The mansion remained a beacon in the landscape of Upper Manhattan as the 1920s gave way to the 1930s. Mid-rise apartment buildings, Columbia Presbyterian Hospital, and the East River are visible in this photograph. The decorative widow's walk, dating to the original construction in 1765, made the mansion distinctive in the 18th century. It is still one of the features that visitors see first, and it marks the house as a Neoclassical structure. One can imagine the view enjoyed by the Morrises and Jumels from this spot, as well as the strategic thoughts that George Washington must have had as he gazed out toward the river.

43

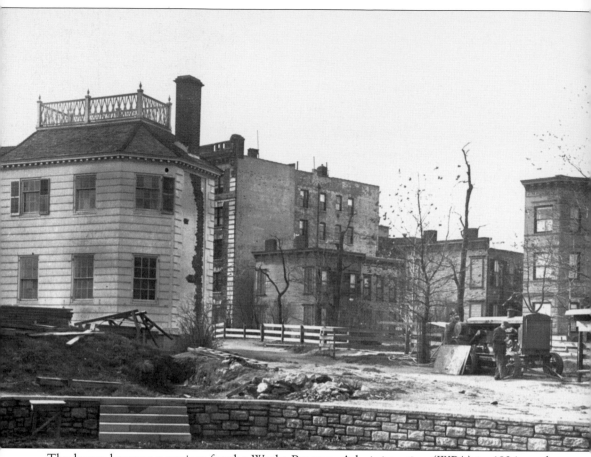

The house became a project for the Works Progress Administration (WPA) in 1934, as the grounds and front entrance were once again redone. Among the projects were the sunken garden (foreground), which took shape in the configuration it is today; the stone paths; and the larger, more welcoming entranceway.

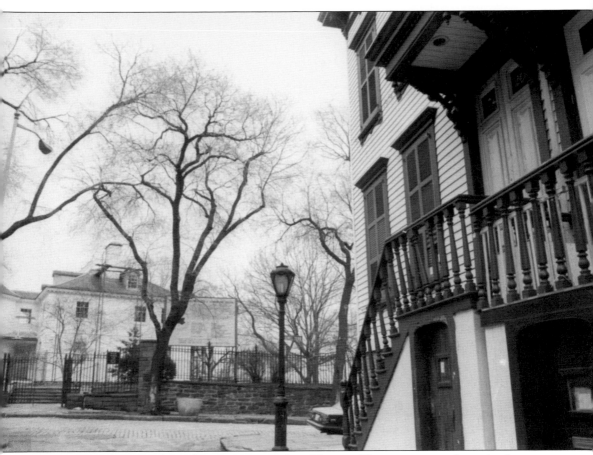

Located directly across from the mansion is Sylvan Terrace. These two rows of wooden houses are thought to be on the footprint of the original entrance, which carriages would have traversed to get to the house in 1765. Constructed in 1882 as housing for working-class families, the homes at the terrace are still private residences today.

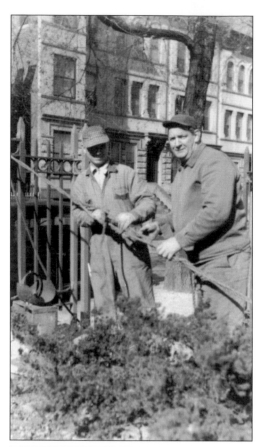

The entrance to the mansion seemed to constantly be in the process of repair, restoration, or renovation. Workers redesigned the gate and entrance in the 1950s, creating a wrought-iron fence that encircled the property. The front wooden gate was made smaller in scale and more in keeping with the times. In addition, the pillars with the urns were removed, and the overhead arch was made dramatically smaller. Guests would now enter and see a bronze sign describing Washington's headquarters and be directed around to the main porch to enter the museum. The next phase of the DAR era had begun.

Gladys V. Clark, president of the Washington Headquarters Association, is seen on the right in the 1950s. The DAR chapters involved in the mansion during this period wanted to alter the interpretation, from solely displaying artifacts to offering fully furnished rooms focusing on the various time periods of the house's history. However, the focus of many, if not all, events and functions at the mansion still had a very patriotic bent. Washington's birthday was still the highlight of the year, and the members of the museum came out in full force for it. In the picture below, a DAR member poses with one of the cannons, which stood guard outside the front entrance for the majority of the 20th century.

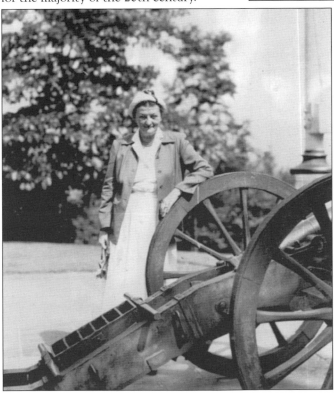

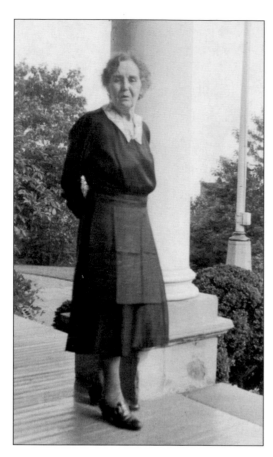

The DAR took many photographs of the members of each chapter. Shown here are Mrs. Steffens and Mr. Steffens. Visiting the mansion was a formal affair for people in the mid-20th century, and the dress reflects this. This era of the DAR included a changing idea of how a historic house should and could be run. The various chapters opened the doors to the community and to new residents who wanted to join in and take pride in the historic landmark right outside their doors. This generation of the DAR would shape the interpretation of the mansion still seen in the museum today.

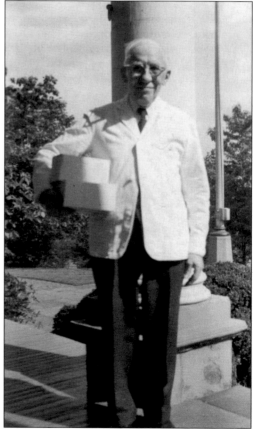

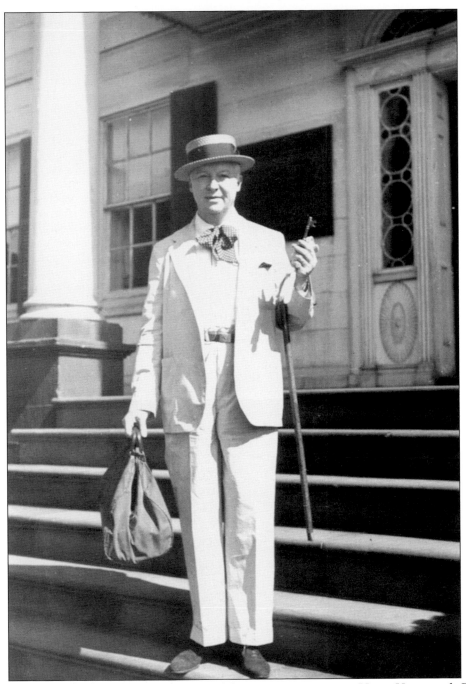

The man leading the new interpretive plan of the mansion was curator Henry Harrison de Frise. Gone were Shelton's prints and glazed cases and the cabinet-of-curiosities style of display. The rooms were to be fully furnished in various styles, and the items inside were to match the year the curator chose for that space. The DAR focused less on collecting patriotic or Colonial Revival works and more on attempting to acquire items that had belonged to the mansion's past families. De Frise, along with the subsequent presidents of the Washington Headquarters Association, worked together to make this happen, unlike Shelton and the original generation of the DAR.

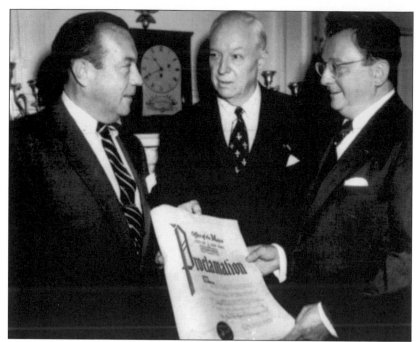

Henry Harrison de Frise (center) is pictured here with New York City mayor Robert Wagner (left) and Dr. Edward Certion. They are gathered around a proclamation from the office of the mayor, but the subject of the proclamation is not known. The caption dates the photograph to October 1957.

Special guests to the mansion included descendents of some of the more famous inhabitants or guests. Here, the current Count de Lafayette is pictured on the front porch of the mansion, flanked by a Mr. Carpenter. The photograph is dated September 1956.

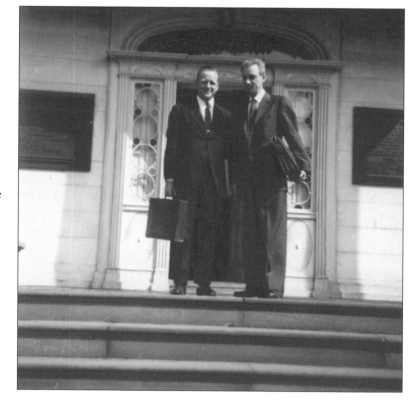

Henry Harrison de Frise, along with both Gladys Clark and Washington Headquarters Association president Harriet Shaw (pictured), elected in May 1954, altered the way guests interacted with the mansion. The strong female presence in the mansion has been constant since its construction in 1765.

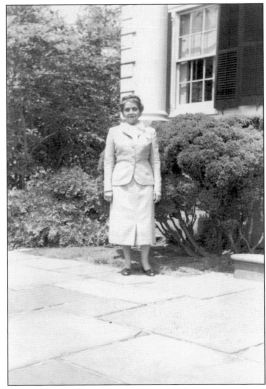

Shown here are some of the women involved in the mansion during the 1960s. They are identified as, from left to right, Carol Finger, Mrs. Banger, Charlotte Livingston, Mrs. Cooper, Mrs. Duncan, Mrs. Nicholas R. Jones, Mrs. Lawrence O. Kupillas, and Ethel G. Turner. At events called *tableau vivants*, participants in period clothing recreate major historical events in the life of the mansion.

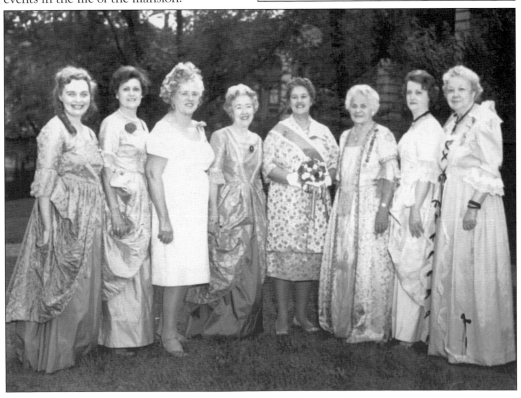

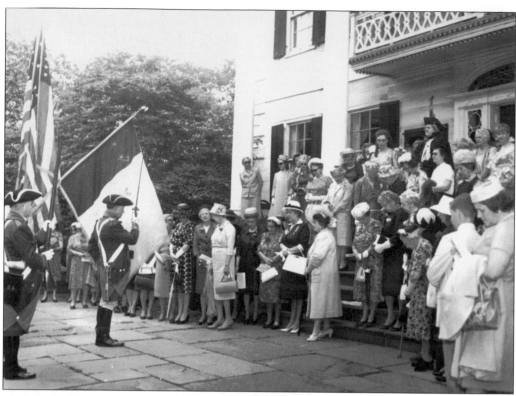

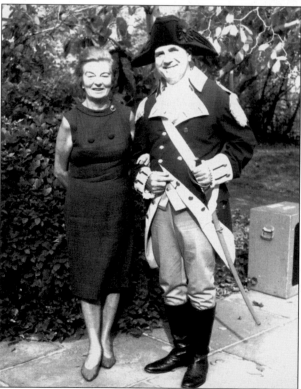

As always, the most lavish events of the year centered on the American Revolution and George Washington. These two photographs were taken on September 14, 1963, for the 187th anniversary of the Battle of Harlem Heights. Members of the large crowd on the front steps (above) have their heads bowed in respect to the military group presenting at the beginning of the event. There was always a gentleman dressed as George Washington (left) presiding over the ceremony. Interestingly, the women of the DAR ran the museum but would focus mainly on the strong male presence in the history of the house. The lives of both Mary Morris and Eliza Jumel were not emphasized during this time, except through the lens of the decorative arts.

Carol Finger (right), in period costume, stands with an unidentified woman in contemporary dress admiring a doll of Eliza Jumel. The woman might be Mrs. Austin, the maker of the doll. The photograph is dated February 22, 1965. The doll was an exact model of a mannequin on display in Eliza Jumel's bedchamber.

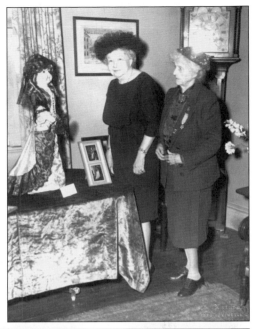

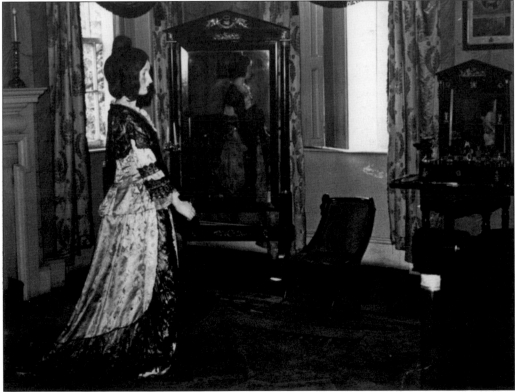

This mannequin wears a replica of a black-and-yellow dress Eliza Jumel owned in the 19th century, portions of which are now owned by the Museum of the City of New York. The mirror, dressing table, chair, and bed belonged to Eliza Jumel and would have been present in her room during the height of her beauty and fame in the mid-1800s.

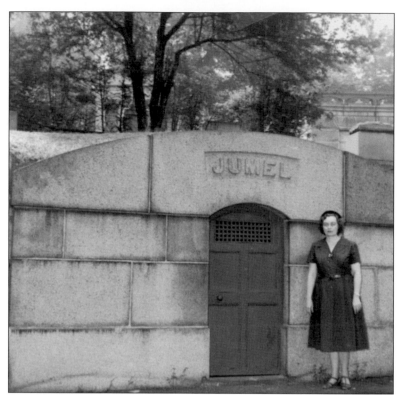

Eliza Jumel is buried only a few blocks from the mansion, although some would say she still makes the mansion her home to this day. Here, Carol Finger stands beside Eliza Jumel's tomb in Trinity Cemetery, at 150th Street and Broadway, in July 1962.

The rumors of the mansion being haunted were seemingly confirmed in the 1960s, when a group of schoolchildren supposedly saw Eliza Jumel. As the story goes, the students were being rowdy, and a woman came out onto the mansion's balcony and told them to "be quiet or go home," and then vanished. Upon going upstairs and viewing the portrait of Eliza Jumel, the class, and teacher, told the museum's educator that this was the woman they saw. Who knows if Eliza still walks the halls today?

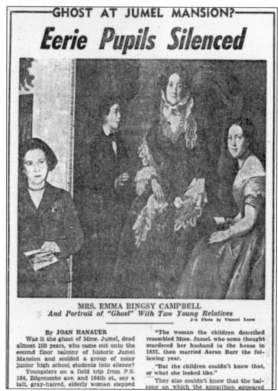

GHOST AT JUMEL MANSION?

Eerie Pupils Silenced

MRS. EMMA BINGSY CAMPBELL
And Portrait of "Ghost" With Two Young Relatives
J-A Photo by Vincent Lopez

By JOAN HANAUER

Was it the ghost of Mme. Jumel, dead almost 100 years, who came out onto the second floor balcony of historic Jumel Mansion and scolded a group of noisy junior high school students into silence?

Youngsters on a field trip from P.S. 164, Edgecombe ave. and 164th st., say a tall, gray-haired, elderly woman stepped

"The woman the children described resembled Mme. Jumel, who some thought murdered her husband in the house in 1832, then married Aaron Burr the following year.

"But the children couldn't know that, or what she looked like."

They also couldn't know that the balcony on which the apparition appeared

Carol Finger kept the patriotic traditions of the mansion, and its origins, alive through the 1960s. The combination of the costumed interpretative events and the more contemporary community outreach allowed for the museum to gain a new level of exposure and importance.

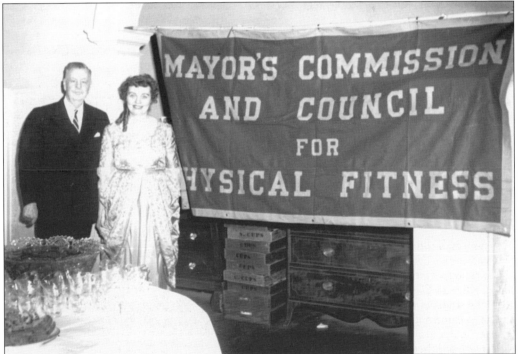

Carol Finger was instrumental in bringing various community and citywide organizations into the mansion and creating partnerships with them. Here, she poses with C. Shelby Carter in front of a banner for the Mayor's Commission and Council for Physical Fitness in June 1966. Civic engagement was at the core of the beliefs of the DAR and was part of the role it felt the mansion should fulfill.

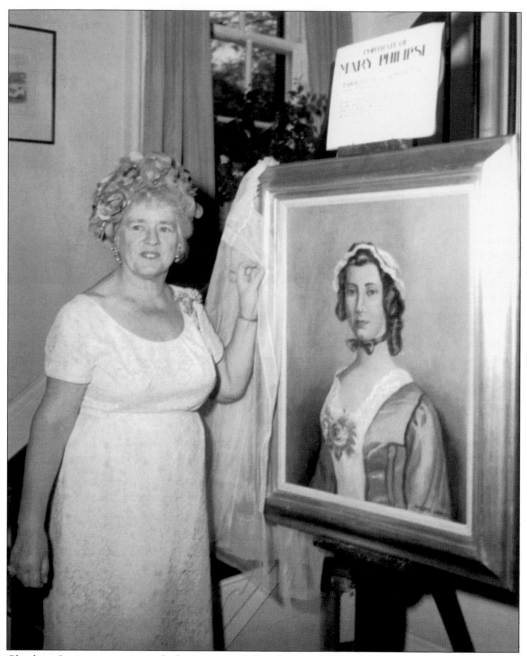

Charlotte Livingston poses with the portrait of Mary Philipse Morris that she donated to the mansion on September 14, 1963. Carol Finger, president of the Washington Headquarters Association in the 1960s, assisted in securing loans for the museum and encouraging people to donate items with direct historical connections back to the mansion.

The military played an important role at the mansion, both historical and contemporary. For events like the Battle of Harlem Heights and George Washington's birthday, there were always historical reenactors present in the guise of the Continental army (on the right). The mansion also hosted groups such as the New York Military Academy. Shown below on February 22, 1965, is a group of young men from the Honor Guard of Cadets from the Cornwall Academy.

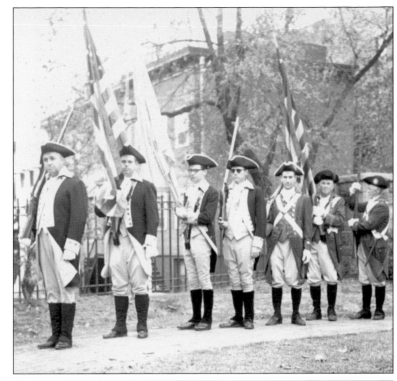

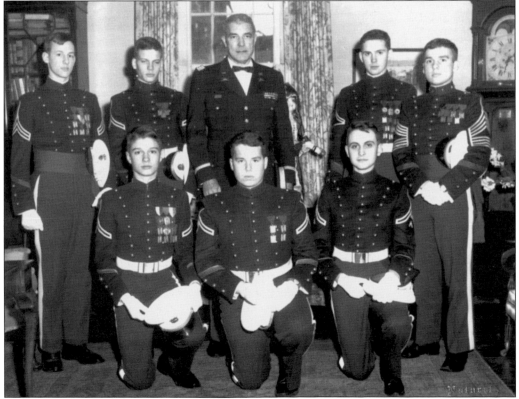

These photographs from a modeling shoot demonstrate how the mansion was used as a backdrop for film, television, and photography. The models, dressed in the height of 1960s fashion, pose both outside and inside the mansion. The idea of the house as a "relic" from the past was very attractive to model designers and photographers, and this still holds true today. Such activity showed the changing idea of how the house could be used and thought about—not only as a teaching tool, but also as a business that could heighten its profile.

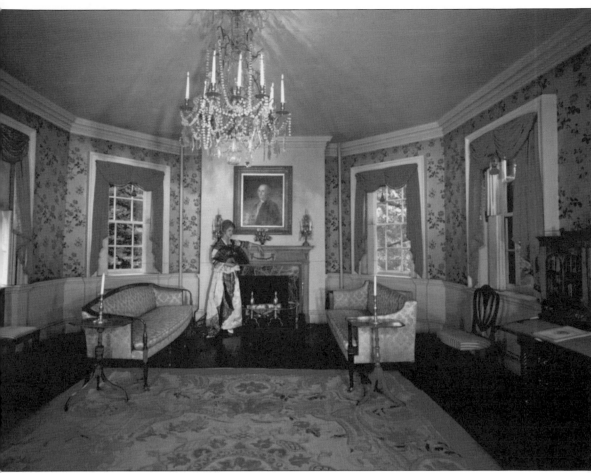

This photograph was taken in the Octagonal Drawing Room in 1964. Records indicate that it was for the Sunday *New York Times* magazine section. At center, an unidentified woman stands at the fireplace dressed in period costume. Similar to the other modeling photographs, this reflects a new way the mansion was marketing itself, appealing to those who appreciated the historic preservation aspect of the house while also incorporating modern fashion photography.

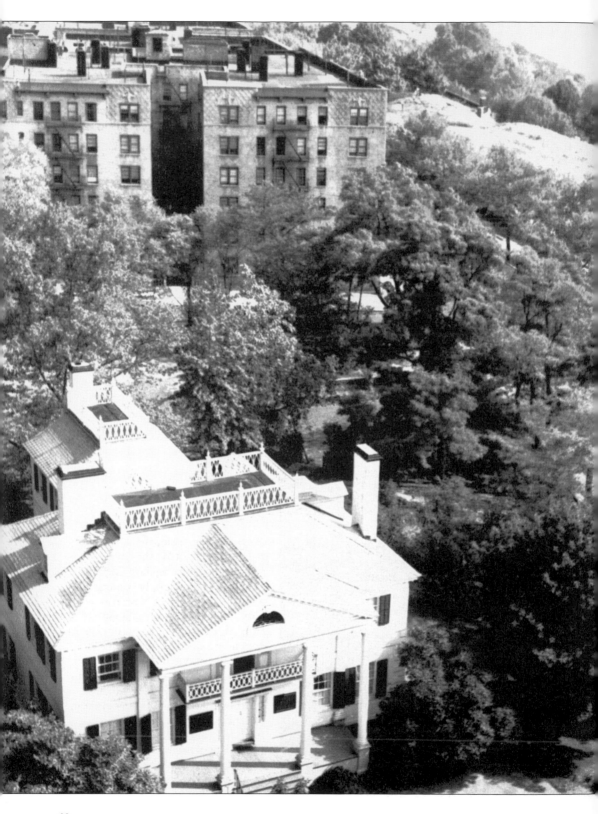

As the 1970s began, the neighborhood of Washington Heights was once again going through a transition, becoming a fairly rough area of New York City. The DAR had now gone through three generations of women who maintained and secured the house as a national site of historic preservation. The mansion now was surrounded by mid-rise apartment buildings, brownstones, and Harlem River Drive. The interpretation of the house was still rooted in the patriotism of the start of the century, but the stewards of the mansion would need to modernize to make the house relevant to a new generation.

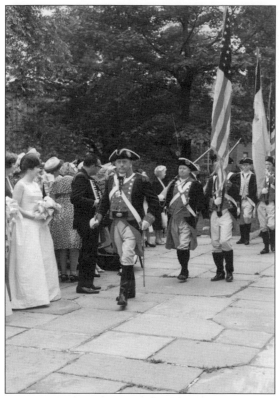

The 1976 commemoration of the Battle of Harlem Heights held special meaning as America celebrated its bicentennial. Large crowds came to see the Revolutionary War reenactors and participated in cooking demonstrations and tours of the house. Here, "Nicholson's Brigade" interacts with visitors in Roger Morris Park on September 18, 1976. This decade saw an increase in the educational mission of the mansion, with more of a focus on opening its doors to families and school groups to inform the next generation about American history. With the changing face of Washington Heights, the goal was to imbibe the American spirit into all programs for all ages.

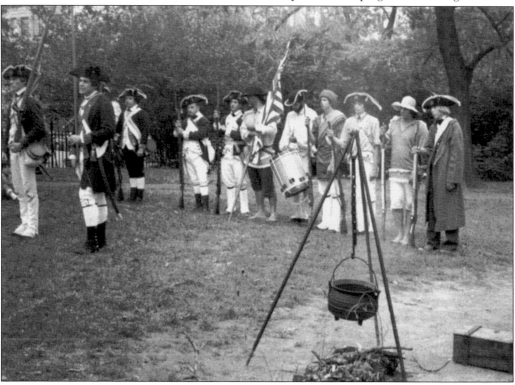

The tradition of costumed events continued in the 1970s, as the period rooms were opened up for evening dances and dinners. The events still relied on the traditional views of historic interpretation and the model begun in 1907 by the first generation of the DAR, who viewed the house as a time capsule to be preserved.

Donors to the mansion were welcomed as if it was their home, and many photographs demonstrate this. Here, Mr. and Mrs. Jerome Neuhoff play chess in the back parlor area in 1972. Visitors were allowed to view the home and interact with the people striving to keep it alive in a holistic experience that made the mansion feel less like a museum and more like a lived-in space.

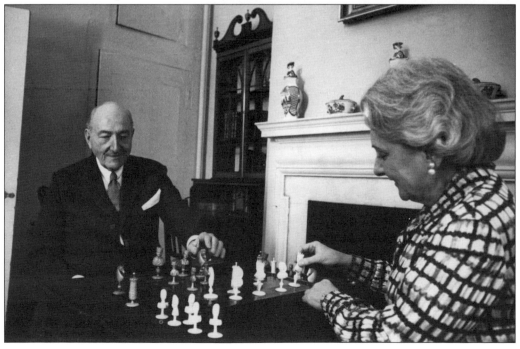

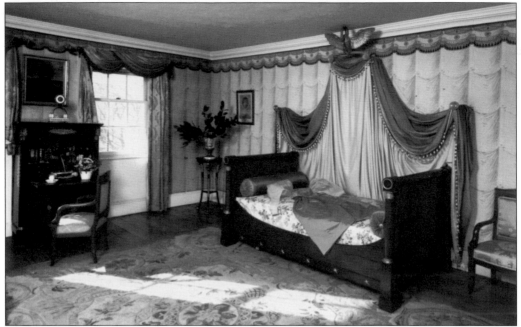

Eliza Jumel's bedchamber is seen here in its 1970s decorative interpretation. The bed and secretary are part of the French Empire suite of furniture known to have belonged to Eliza. The painting over the secretary is of Napoleon Bonaparte, supposedly a close friend of Eliza. The carpet and wallpaper involved speculation and have since been updated to be more historically accurate.

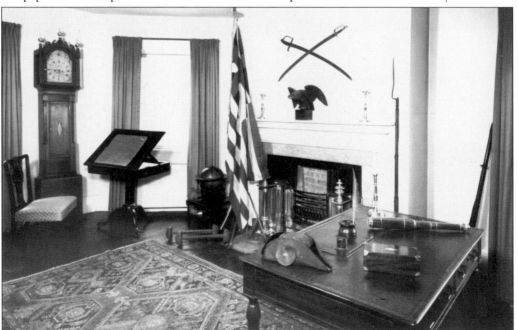

Washington's bedchamber as displayed in the 1970s was the room closest to the traditional model of the William Henry Shelton years. The interpretation involved placing as many Revolutionary War artifacts in the space as possible, even though some were not accurate or were only replicas. Patriotism radiates from every corner of the room.

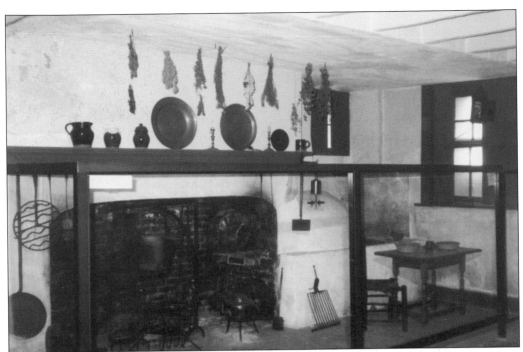

The kitchen in the 1970s was restored to the original 1765 interpretation. The hearth and beehive oven were open for visitors to view. However, the subjects of domestic servitude and slavery were not part of the conversation on tours or visits. The focus was on the Revolutionary War and cooking and home life in that era.

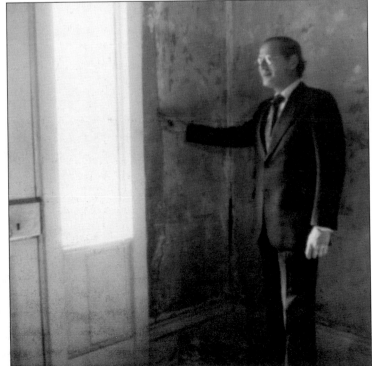

The mansion's age meant that various restoration projects were constantly being done or under consideration. A major project in the mid-1970s dealt with the lower first-floor hallway. Here, an unidentified man removes some wallpaper to demonstrate the presence of the plaster walls underneath and visible damage.

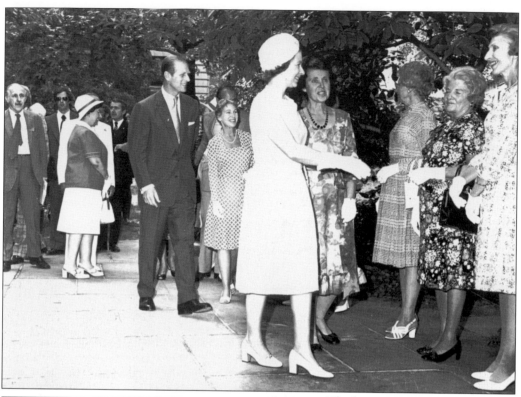

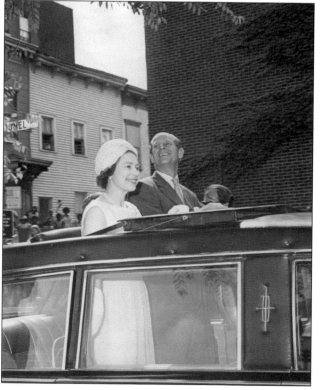

The biggest event of the 1970s for the mansion was a visit by Queen Elizabeth II and Prince Philip for the bicentennial. They came up to the museum on July 9, 1976, and the Morris-Jumel Mansion was their only stop for the day. In the above photograph, the receiving line includes mansion members Virginia Dodge and Jane Stanlin. Walking with Prince Philip is Katherine Parker, a longtime board member. Ann Wood, the president of the Washington Headquarters Association, stands immediately to the right of the queen. On the left, Queen Elizabeth and Price Philip stand up inside their limo, waving to the crowd. Sylvan Terrace is behind them.

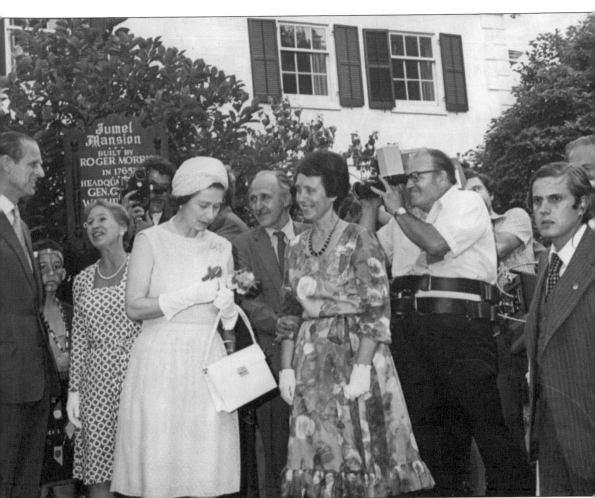

The caption of this photograph from the mansion's archives reads, "Queen Elizabeth with Tussy Mussy from herb garden." Prince Philip stands at far left talking with Kathleen Parker. Note the small boy dressed in a Native American costume. Ann Wood stands to the right of the queen. At this event, the press swarmed the mansion; two cameramen record the event as the queen's security detail keeps a close eye on the proceedings.

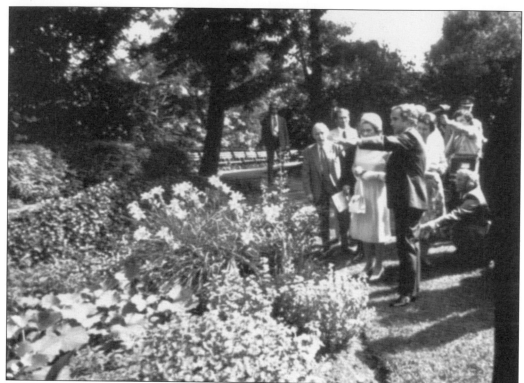

John Henry Thomas, a long-term volunteer docent at the mansion, gives a garden tour to Queen Elizabeth in Roger Morris Park. Thomas still gives tours at the mansion. There are residents who remember being included in the crowd that walked the grounds with the queen.

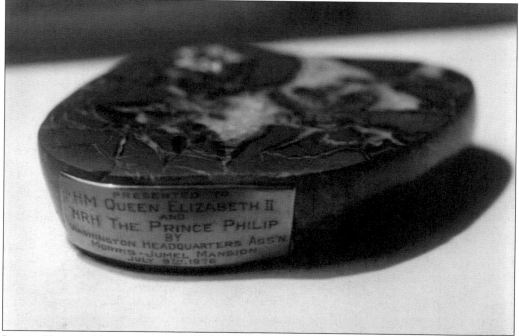

Pictured here is the award presented by Ann Wood to Queen Elizabeth II and Prince Philip.

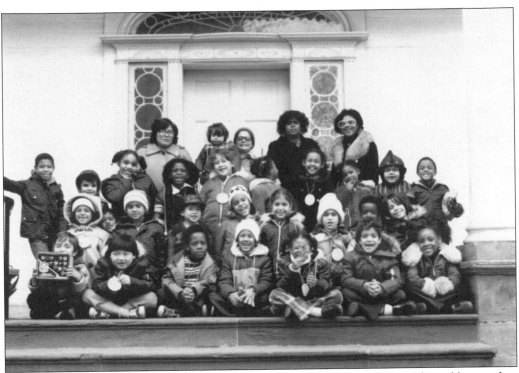

School groups come to the mansion on a daily basis. Pictured on this page is a class of first graders from PS79. The photograph labels indicates that they were at the museum on November 22, 1978. Parents who help chaperone school tours today remember coming themselves as children; perhaps some of them are in these photographs.

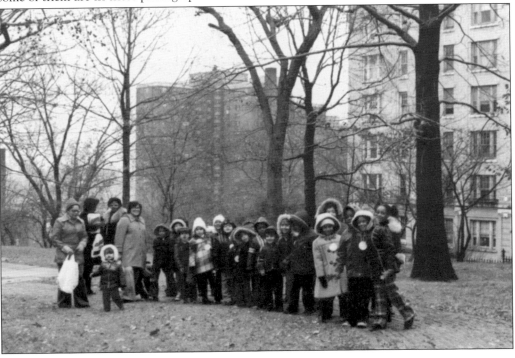

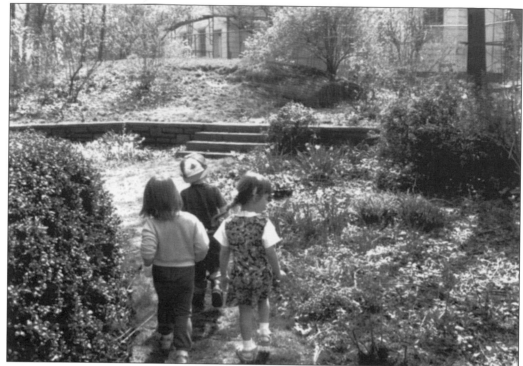

School groups love exploring Roger Morris Park and the Colonial Garden. In the 1970s, the gardens were planted to reflect the 18th- and 19th-century styles of the Morris and Jumel eras. The New York City Parks Department keeps the grounds manicured, allowing visitors of all ages to explore and learn.

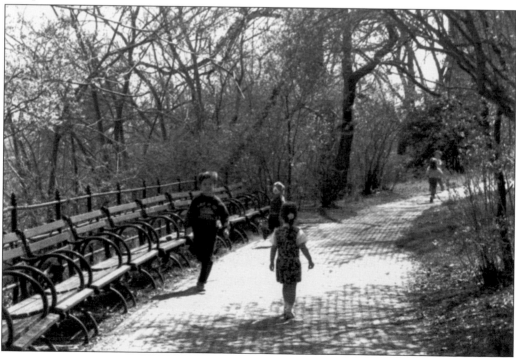

Similar to the earlier visit by the Count de Lafayette, pictured here is Peter Sauger, the sixth-generation descendent of Roger Morris. He was made an honorary member of the Washington Headquarters Association by Ann Wood. This photograph was taken in March 1975.

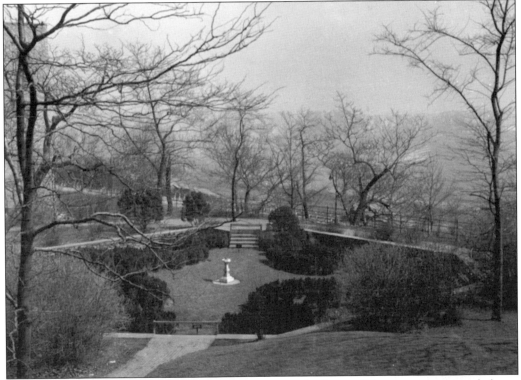

The garden also became a focal point for more events; the heart of the property was and always will be the Colonial Garden area. The sundial (center) creates a focal point for activity in this space, a true oasis in Washington Heights.

This fun photograph depicts one of the Lord & Taylor Christmas windows during the 1985 holiday season. The scene is a dance in the mansion's Octagonal Drawing Room. Note that the wallpaper is the morning glory pattern, which is historically correct for that room. It can now be seen in the mansion's parlor.

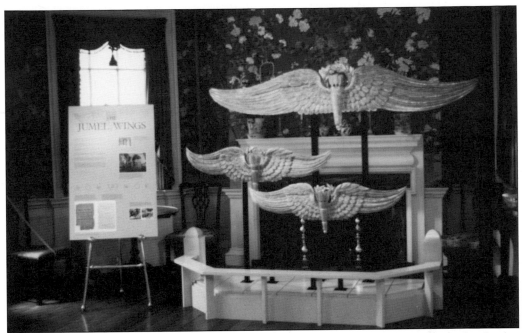

In May 1990, Helen Hayes, the president of Morris-Jumel Mansion, Inc., organized a display called The Wings Fly Home. The wings exhibition was to showcase the newly restored Jumel-era decorative-arts elements coming back to the mansion after an extensive restoration. The rumor has it that the wings once decorated Napoleon Bonaparte's carriage.

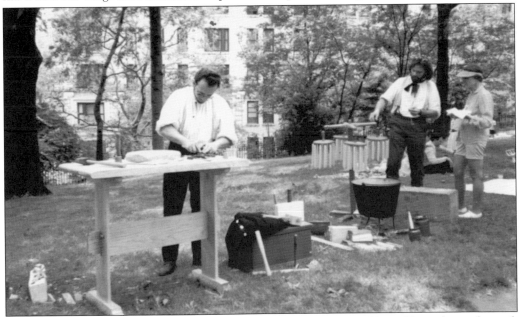

On the 225th birthday of the mansion, in June 1990, a large Historic House Festival was planned, with artisans and fun activities for families. Members of the New York City Parks Department appeared in Colonial dress and demonstrated crafts such as stonecutting and candle making. Here, Don DeFillo (left) and Pat Oles (second from right), both from the parks department, share their knowledge with guests.

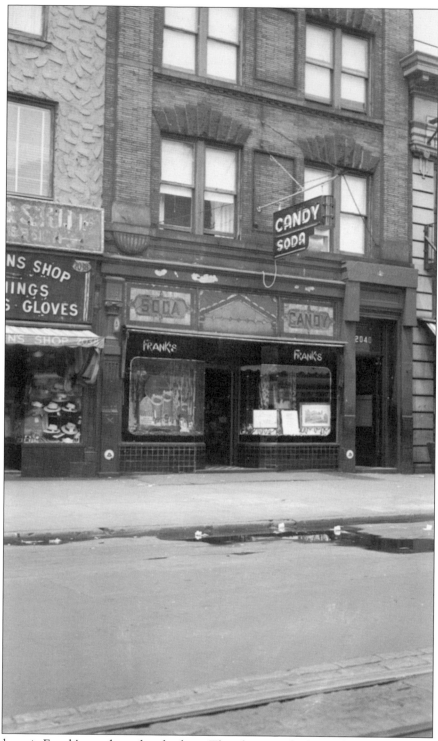

Shown here is Frank's candy and soda shop. The photograph shows the shop from across the street, and one can see an unfinished painting of George Washington and a framed picture of the Morris-Jumel Mansion in the window.

The mansion's location on a hill necessitated a thick, sloping retaining wall to board it on all four sides. This allowed for the mansion to be safeguarded from small-scale rainstorms and other weather elements. However, the wall, made of porous stone, was one of the aspects of the grounds and gardens that the NYC Parks Department needed to keep an eye on. Restoration projects were ongoing throughout the 20th century and continue today.

The latter part of the 1990s saw a major restoration project of the interior of the mansion. Above, the garret fanlight was blocked off prior to painting the second- and third-floor hall and gallery space. The photograph on the left shows the restoration work in George Washington's bedchamber, which consisted of restoring the woodwork, wallpaper, and flooring. Everything in the house needed to be stripped and either repainted or re-wallpapered prior to having guests into the museum.

Five

THE MANSION TODAY
CONTEMPORARY MEETS COLONIAL

The start of a new century brought the mansion into a new era, in which the past is embraced, heritage is cherished, and the future is bright. Colors from Eliza Jumel's bedroom mix with historical photographs to engage visitors and entice them to visit Manhattan's oldest house. There is always something new happening at the mansion.

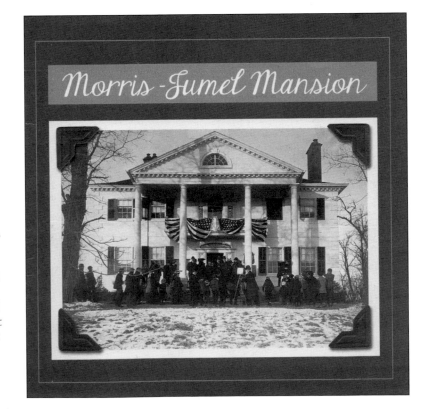

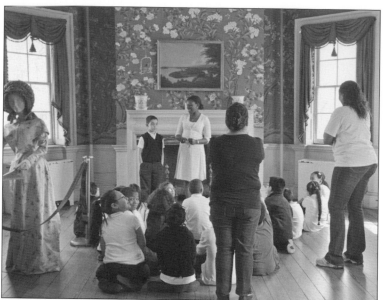

The educational mission of the mansion is still the main goal of the institution. In the last few years, attendance has risen from 2,000 students walking through the doors to close to 8,000 in the 2013–2014 school year. Students of all ages, from preschool through college, come to learn about New York City and American history. (Courtesy of Trish Mayo.)

Educational tours are no longer lecture based, but instead are hands-on explorations of the mansion. Tour guides, such as Leah Charles (pictured), lead students through the house, asking questions and heightening their critical thinking skills. This method harkens back to the years of Shelton and Bolton while bringing the artifacts out of the glass cases for students to interact with, and to make their own conclusions. They become a part of the history of Morris-Jumel Mansion. (Courtesy of Trish Mayo.)

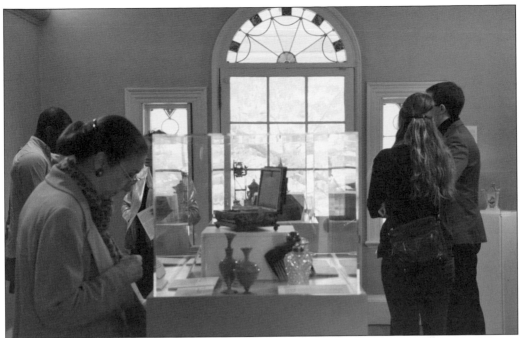

Honoring the memory of Shelton and his display style, the mansion continues to present a variety of special, temporary exhibitions in the second-floor hallway, where he used to sit and pour over books detailing the history of the mansion. The museum has a wide-ranging collection, and the exhibitions reflect this in their scope. The decorative-art pieces of the house, especially those with direct connections to Eliza Jumel, are often displayed for guests to enjoy. The case shown above has glass perfume bottles and a sewing box that belonged to Eliza. Below, guests enjoy an exhibition focusing on the decorative arts, like the inkwell, and prints pertaining to the house's connection to the Revolutionary War. (Both, courtesy of Trish Mayo.)

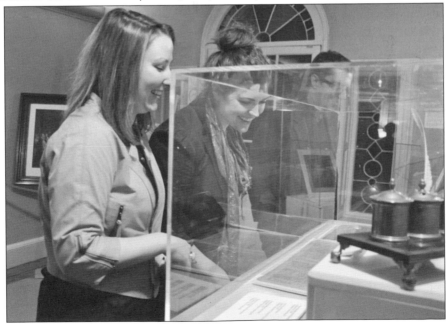

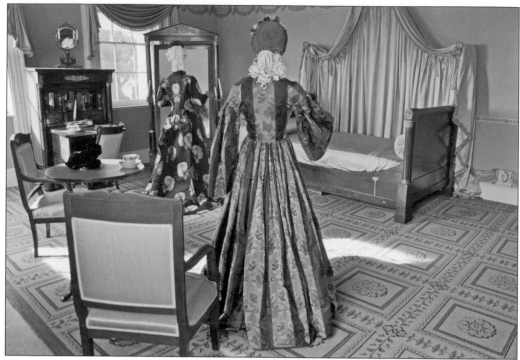

The mansion is significant as a site where visitors can connect with the past and understand what life was like 200 years ago. Exhibitions of clothing and fashion, seen through a historical lens, have always been popular, going back to the DAR era. Here, a mannequin of Eliza Jumel admires herself in the mirror as a friend looks on. The costumes were part of the collection of Empire Historic Arts, which had great synergy with the connection Eliza Jumel had with Saratoga Springs, New York. (Courtesy of Trish Mayo.)

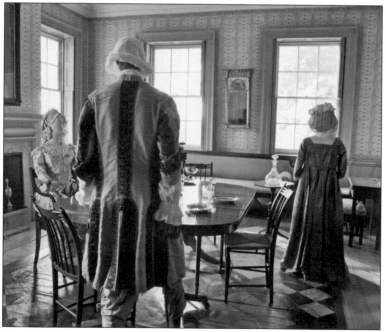

Costume exhibitions work on many levels in a historic house. Visitors can gain a greater understanding of the physicality of a room by seeing life-sized mannequins in context. The notion of the mansion as a summer home owned by a wealthy family who had slaves and servants can be solidified by having three mannequins gathered around the dining-room table, seeing the subtle ways they "interact." (Courtesy of Trish Mayo.)

It is amazing how history repeats itself. Similar photographs taken close to 50 years apart convey the same emotions. In the 1960s, president of the Washington Headquarters Association Carol Finger posed alongside Eliza Jumel's tomb (see page 54). Here, actress Kimberly Barrante, dressed in the guise of Eliza, stands in the same spot. (Courtesy of Trish Mayo.)

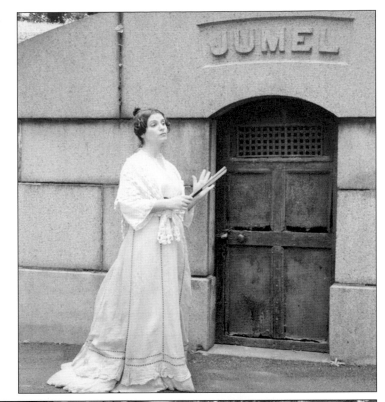

Eliza Jumel will always be the most intriguing figure in the story of the mansion. In recent years, a newfound emphasis has been placed on her role as the longest resident of the house. Both 19th- and 20th-century gossip has allowed her fame, or infamy, to grow. (Courtesy of Trish Mayo.)

The mansion continues the tradition of the DAR's *tableau vivants*, with staff members dressed in period clothing and representing figures from the mansion's history. Here, educator Emily Provance represents Mary Philipse Morris at the museum's annual Chocolate Day celebrations, which touch on how chocolate was used by the Morrises in the 18th century and how Stephen Jumel imported it in the 19th. (Courtesy of Trish Mayo.)

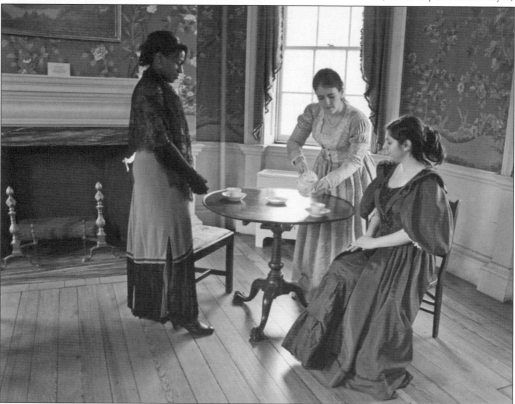

Female figures in the history of the mansion have come to the forefront in recent years and are honored during events like Chocolate Day. Here, Mary Morris (Emily Provance) serves tea to Madame C.J. Walker (Leah Charles), one of the wealthiest women who lived in Harlem near the mansion, and Eliza Jumel (Diane Russo). Guests are invited to join in the conversation and learn from firsthand accounts of history. (Courtesy of Trish Mayo.)

The traditional style of presenting events and historical reenactments is not enough to appeal to younger audiences or different demographics of guests, who might otherwise not attend an historic house museum. The mansion has reached out and thought outside the box to create exhibitions and programs that embrace its mission and history in new ways. (Courtesy of Trish Mayo.)

The Loves of Aaron Burr was an exhibition that took the mansion to a whole new level in terms of contemporary art in a historic home. Artist Camilla Huey, a local resident, spent 10 years researching the eight women whose lives intersected with Aaron Burr. His second wife, Eliza Jumel, was the centerpiece of this exhibition. The artist created an exact replica of the yellow-and-black dress known to have belonged to Eliza (above) and currently in the collection of the Museum of the City of New York. Each sculpture was rooted in fashion, with a dress or a corset as its base and historical items surrounding it. The corset pictured below represented Margaret Montcriffe, Aaron Burr's lover during the Revolutionary War. She was turned over to the Continental army for treason based on paintings of flowers she created, which were thought to have secret messages for the British troops. (Courtesy of Trish Mayo.)

Tableau vivants took on new meaning as the event "Corseted" brought the eight women of The Loves of Aaron Burr to life and allowed guests to interact with these colorful characters. The Morris-Jumel staff is always up for anything, and here, Naiomy Rodriguez portrays Margaret Montcriffe in George Washington's bedchamber. (Courtesy of Trish Mayo.)

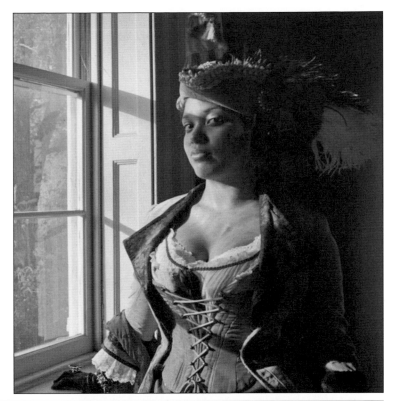

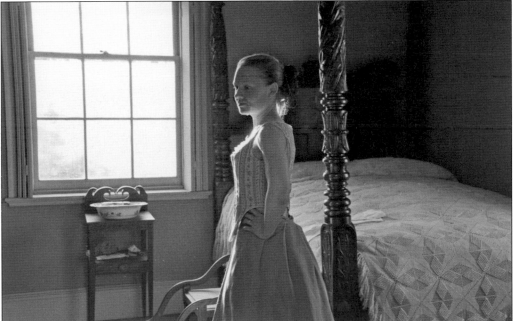

For "Corseted," the barriers between guest and actress were taken down as people were allowed to go into the mansion's period rooms to get up close and personal with the characters. Morris-Jumel's archivist, Emilie Gruchow, played Jane McManus, the woman who coined the phrase "Manifest Destiny" and was the rumored lover of Aaron Burr. (Courtesy of Trish Mayo.)

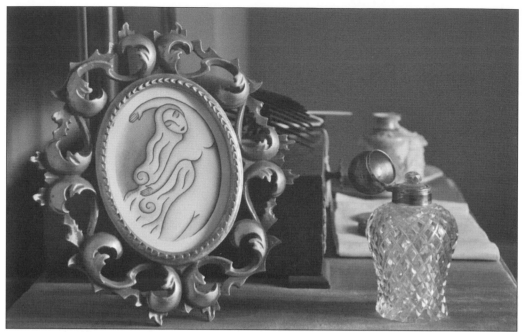

The staff of the mansion believes strongly in supporting the work of local, Upper Manhattan artists, who can come into the space and think creatively about the site and the museum's collection. Andrea Arroyo, a well-known Mexican American artist, used decorative arts artifacts from the mansion's permanent collection to complement her colorful paintings of dancer-like females from Classical mythology. Arroyo shares the vision of the mansion to bring the women of the house to the forefront. (Courtesy of Trish Mayo.)

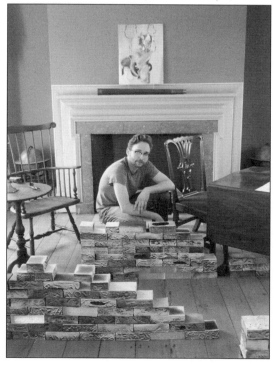

George Washington's bedchamber can be a site for corsets, as well as for a wall of resin bricks. This "fort" was created by artist Peter Hoffmeister (pictured) out of casts of New York City Parks Department signs throughout Upper Manhattan. Displayed in George Washington's room, the piece facilitated conversations about the American Revolution and created a sense of place and historical information through time. (Courtesy of Caroline Drabik.)

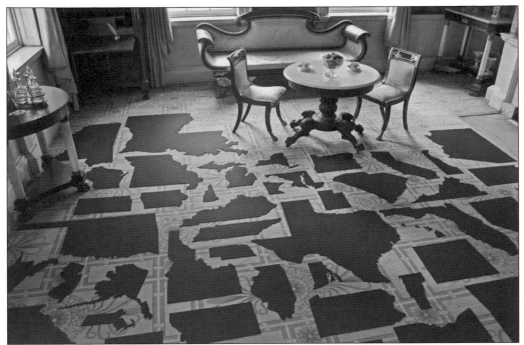

Hoffmeister was invited back to the mansion a year later to develop a solo exhibition, entitled Unpacked. Definitely, the most conceptual exhibition to date at the mansion, his pieces pushed the boundaries of installation art, making the visitor think about history in a new way. The work, entitled *Ball and Chain, Per Capita*, was laid on the parlor floor (above), partly to remark on patterns in carpets during the 19th century, but, more importantly, to draw a parallel between the slave population in each state during the Civil War and the direct correlation to the prison populations of each state today. The artist's use of black felt for this piece was a deliberate choice. The other piece, *38th Parallel*, was hung by invisible wire above George Washington's bed (below). The artwork was a metaphor for the American Revolution, Manifest Destiny, and America's historic and contemporary wars. (Both, courtesy of Peter Hoffmeister.)

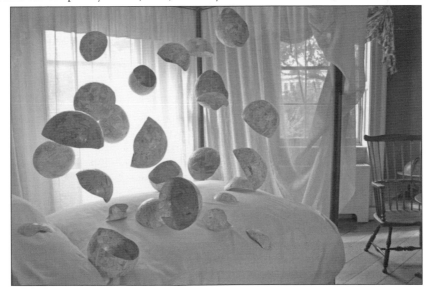

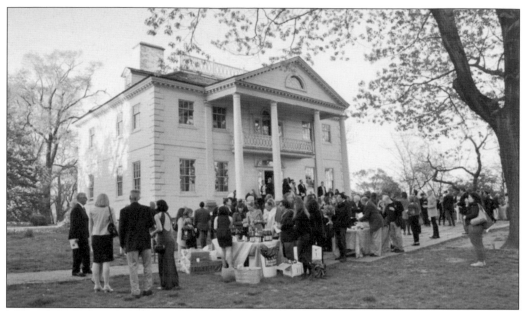

Morris-Jumel now sees approximately 100–200 people attend each of the exhibition openings since it began the contemporary-art series. Guests vary, from traditional museum and historic house supporters to younger, local residents who are exploring the mansion for the first time. The civic responsibility of the DAR is still a strong component of the mission of the museum as it reaches out to the community. (Courtesy of Trish Mayo.)

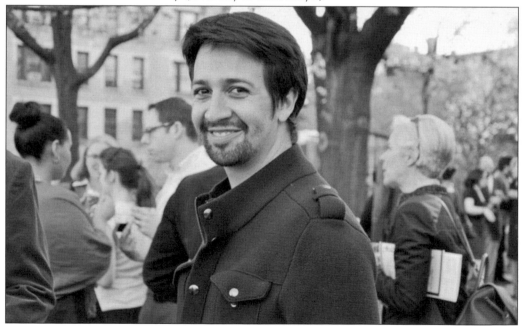

Collaborations are also key to making the mansion reach large and diverse audiences. Pictured here is Lin-Manuel Miranda, the writer and star of the Tony Award–winning musical *In the Heights*. He still works and lives in Upper Manhattan and supports centers of art and history such as Morris-Jumel. He has even composed music for his musical *Hamilton* in Aaron Burr's bedchamber, an ironic mix of history and contemporary culture. (Courtesy of Trish Mayo.)

Another rich tradition at the mansion is music. The Octagonal Drawing Room was created specifically for its acoustics and ability to accommodate guests for a concert. The museum uses the space today for the same purpose. Resident group Brooklyn Baroque performs at least three to four times a year on period instruments and compositions that would have been popular during the time of Eliza Jumel. (Courtesy of Erik Ryding.)

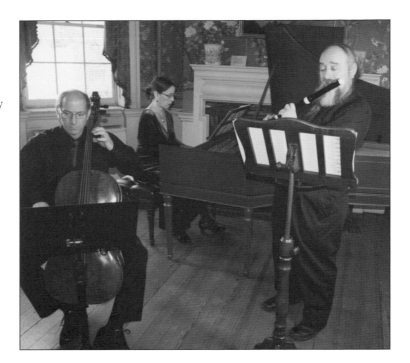

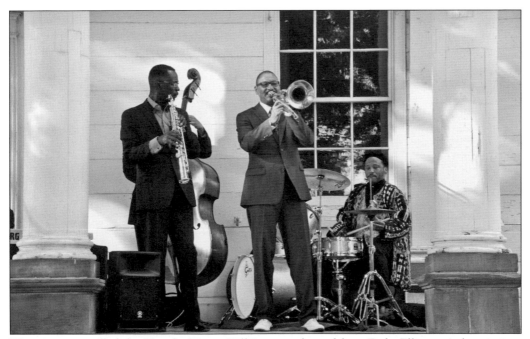

The mansion, called the "Jewel of Sugar Hill," as paraphrased from Duke Ellington's description, was perfectly situated to host jazz greats such as Dizzy Gillespie and Lena Horne, who walked its halls and lived directly across the street in an apartment building called "the Triple Nickel," at 555 Edgecombe Avenue. Today, the annual JazzFest in August is one of the most-attended events, with over 500 people listening as music fills the air in Roger Morris Park. (Courtesy of Trish Mayo.)

Guests arrive at the mansion for a special experience, where they know they will be transported in time for a unique afternoon of history and fun. Here, Emilia Otto and a young lady dress in their Sunday best for an annual end-of-summer party. (Courtesy of Trish Mayo.)

Whether for day or evening events, the mansion serves as a backdrop for learning and entertainment. The wine-tasting series draws upon the historical records of Stephen Jumel's vocation as a wine and dry-goods merchant and incorporates actual wines he would have sold with items such as chocolate that records show he traded in. Pictured here are director of the Historic House Trust of New York City, Frank Vagnone, and his daughter Claire. (Courtesy of Trish Mayo.)

While the mansion is a teaching tool, Roger Morris Park allows students to learn about the mansion's location in New York City geography. The view from the front porch has changed dramatically since 1765, but the elevation of the mansion is still impressive. (Courtesy of Trish Mayo.)

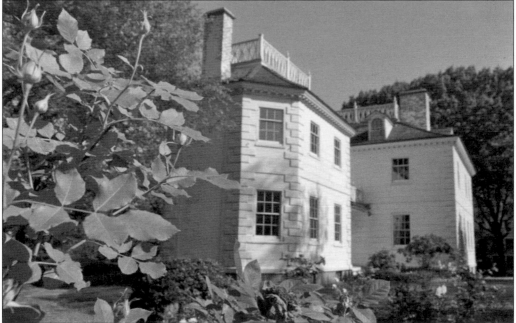

The park has become a site for important historical plants, especially roses. The mansion is now one of a handful of Heritage Rose locations, and the rose garden located directly behind the Octagon contains more than 20 different types of roses; for some, only one or two of their type remain, and some are the only example of their type in North America.

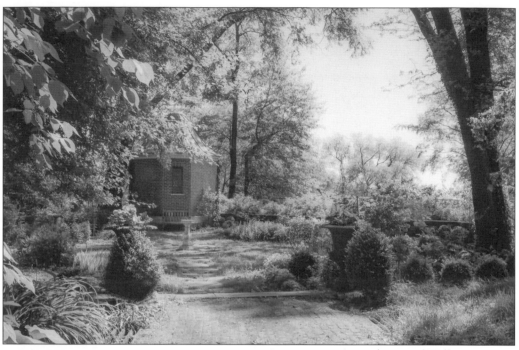

As in the era of William Henry Shelton, the Sunken Garden today has become an area where the neighborhood comes together in a peaceful green space. In recent years, with the help of dedicated volunteers and landscape architects, the garden has been transformed into a 19th-century ornamental garden, similar to what would have existed in the Jumel era. (Courtesy of Trish Mayo.)

The path around the Sunken Garden takes visitors past rows of flowers and roses to the community vegetable garden. Popular with the residents of the neighborhood, historic seeds take root and grow into eggplant, squash, tomato, corn, and grapes. This area serves as a reminder of the original purpose of the property during the Morris era—a large country farm. (Courtesy of Trish Mayo.)

No visitor is too young to enjoy the wonders of Roger Morris Park. Families in the Upper Manhattan communities of Washington Heights and Inwood use the garden and park as a site for family picnics, baby showers, and birthday parties. The mansion serves as a backdrop to all this, as new memories and history are made on a daily basis. (Courtesy of Trish Mayo.)

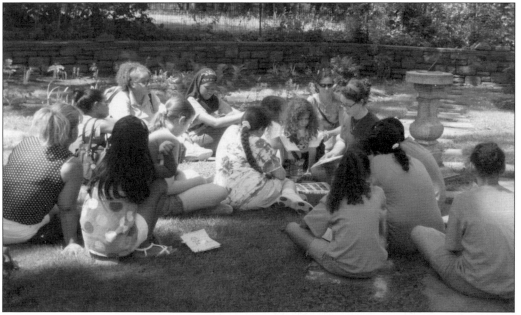

In summer, local camp groups, like this one from the Police Athletic League, take part in workshops and lessons in the garden. Educators like Christina Ruiz, the young woman wearing glasses with her hair in a bun and sitting by the sundial, lead groups in explorations of plant anatomy, the history of the uses of flowers, and how to tend a garden. Such programs bring the garden to life, as families work together to make it grow. (Courtesy of Trish Mayo.)

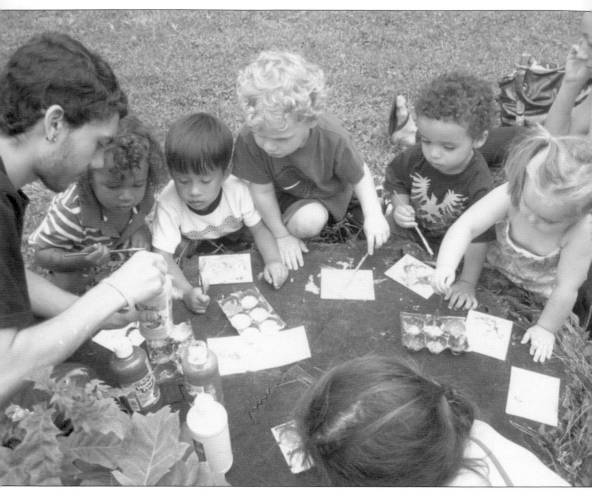

Students as young as preschool age can also enjoy the garden, with educators who will teach them how to paint or count the rings on a tree stump. The goal for the mansion is to create a positive museum experience for all visitors, young and old, both inside and outside the physical structure of the museum.

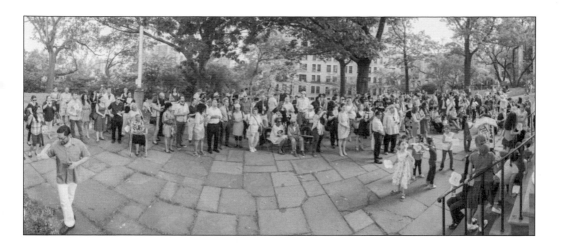

The mansion continues to expand its reach to the local neighborhood by hosting organizations from Upper Manhattan and around the city. In 2013, the museum helped the Northern Manhattan Arts Alliance (NoMAA) celebrate its 10th anniversary by hosting the kickoff party for the annual Uptown Arts Stroll in June. The mansion saw one of the largest crowds gathered on the front lawn and porch area to listen to local jazz musicians and honor local talent and dignitaries. Partnerships with organizations like NoMAA ensure that the mansion attracts new audiences from the area, especially younger people who are just moving into the area and come to see the mansion as part of their daily lives. (Both, courtesy of DJ Boy.)

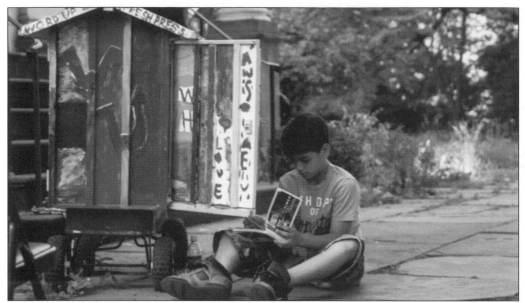

Washington Heights never had a local, independent bookstore until Word Up Books opened its doors. While the community store was closed down due to its moving, the mansion assisted in setting up a mobile book cart designed by Word Up and repainted by museum staff. The cart participates in a give/get policy, in which anyone can take a book for free and place books in the cart as well. Many local residents, of all ages, pick a book out of the cart and sit in the park to read. (Courtesy of DJ Boy.)

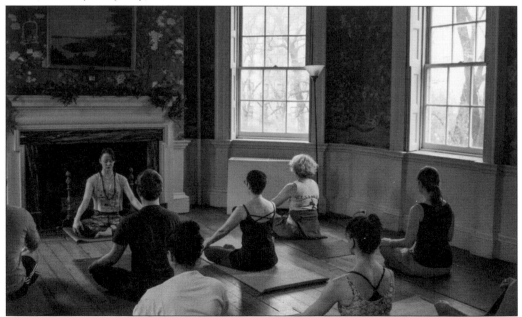

Green spaces are hard to come by up in the Heights, and the mansion's garden is a perfect spot for residents to come and relax. More residents are starting their own businesses, and the mansion believes in partnering with them, as well. Awesome Asana Yoga is one such case, taking place in the gardens during the warm months and in the Octagonal Drawing Room in the winter. (Courtesy of Spiro Galiatsatos.)

The Octagonal Drawing Room was built for its large size and ability to accommodate an audience. This comes in handy for events today, as the space is increasingly used for theatrical productions. For Halloween 2014, the mansion hosted a site-specific production of *The Turn of the Screw* by the Everyday Inferno Theater Company. The show, a Victorian ghost story set in a parlor, was perfect for the mansion and its haunted history. The theater company is run by two women; with the female staff and historical characters of the mansion's past, it seemed like a perfect collaboration. (Courtesy of Trish Mayo.)

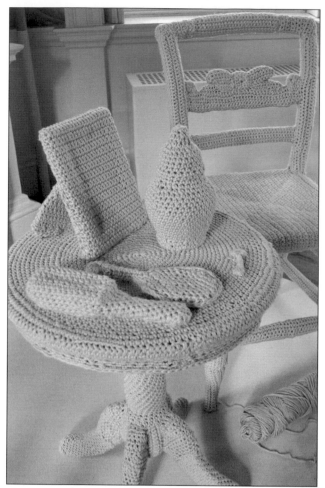

The mansion embraces programming and exhibitions that incorporate underserved museum audiences—in particular, groups with special needs, such as the sight-impaired and children with autism. Touch History, an exhibition installed in the fall of 2014, included both historic and modern items crocheted by artist Kathleen Granados to create a tactile experience for all visitors. The incorporation of different learning styles is something new in the field of historic houses, and it is key to the continuing relevance of the mansion. Other installations include large-scale text to allow sight-impaired visitors to interact with the history of the house.

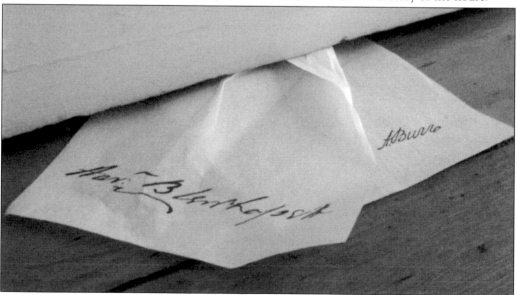

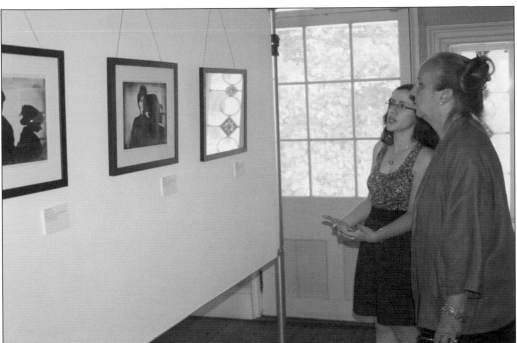

For a cultural institution in New York City, the mansion is one in a sea of organizations that need assistance for various projects. It is important to maintain a relationship with local elected officials and to create programming that allows them to participate and feel like a stakeholder in the life of the mansion. Above, museum director Carol S. Ward (left) and Manhattan borough president Gale Brewer view Ladies of the House, a photography exhibition by Trish Mayo. In 2014, Brewer was instrumental in gathering support for a much-needed exterior restoration project, which included restoring and replacing some original woodwork, seen right.

The mansion is in constant need of conservation, restoration, and repairs, both inside and out. The New York City Parks Department and the Historic House Trust of New York City (HHT) give assistance to the mansion in forms of funding and helping hands. On the left, HHT head preservationist Rebecca Brainard repairs the sash cords of a window in the Octagonal Drawing Room. Some of the cords date as far back as the late 18th century. It is painstaking work to recreate the look and feel of the craftsmanship of over 200 years ago.

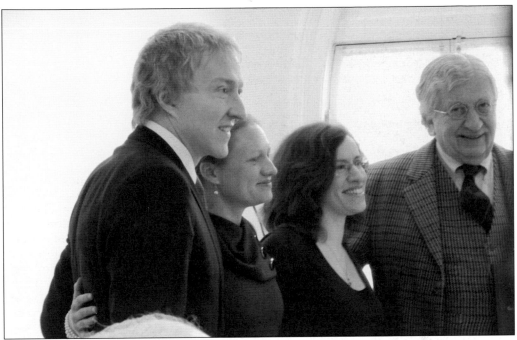

Helping the mansion increase its profile and improve its finances was the discovery of a document in the museum's archives in mid-2013. The document, entitled "The Twelve United Colonies, by their Delegates in Congress, to the Inhabitants of Great Britain," was written by Robert R. Livingston. Pictured above from left to right are Leigh Keno, Emilie Gruchow, Carol S. Ward, and James Kerr. The mansion's archivist, Gruchow, discovered the document in the museum's attic, and it was sold at auction in early 2014. The find solves a 200-year-old mystery involving the shaping of the United States. The discovery of the original draft at the Morris-Jumel Mansion shows how this renowned home has been a witness to history. Below, Keno addresses the audience. (Both, courtesy of Marion Ward.)

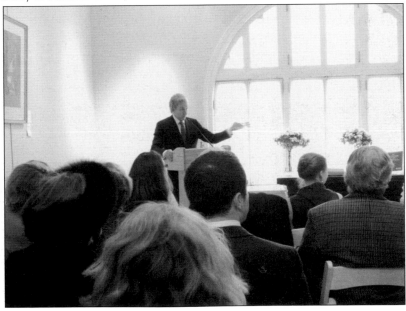

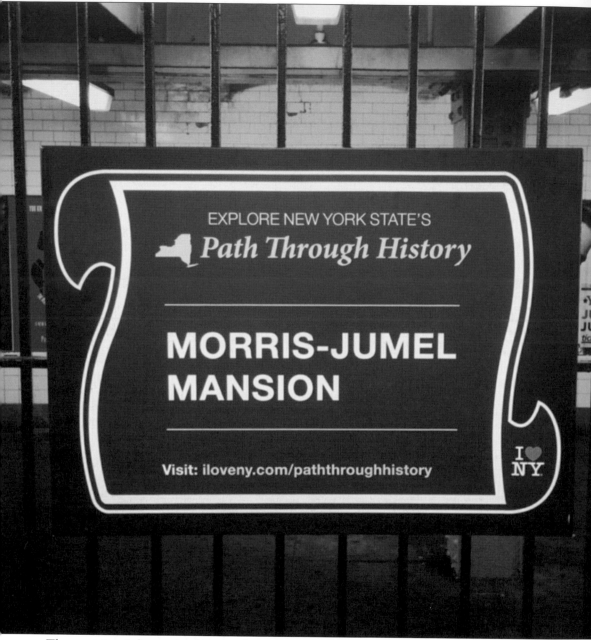

EXPLORE NEW YORK STATE'S

Path Through History

MORRIS-JUMEL MANSION

Visit: iloveny.com/paththroughhistory

I ♥ NY

The mansion is becoming known throughout the city and the state, in part through a new partnership, begun in 2014, Path Through History. The statewide program originally selected five historic sites from each borough, and the mansion was one of the places selected in Manhattan. Governor Andrew Cuomo was instrumental in beginning this program, and the hope is to expand it in the future. An exciting element of this partnership was a long-needed sign for the mansion in the 162nd Street subway station. This allows tourists and local residents to know about the mansion and have clear directions on how to get there. Often, a hurdle for visitors to the mansion involves location. This sign, although simple, is making a huge difference to the foot traffic of the site.

All the exciting programs, exhibitions, and events at the mansion could not be completed without a dedicated staff. The motivation of those early generations of the DAR to protect and preserve the house has been passed down to today's museum professionals, who have become like a family. Each person is in charge of a department, but there is a lot of overlap in the daily operations of the museum. In the tradition of Gladys Clark and Carol Finger, the current Morris-Jumel staff brings their own talents in art history, history, museum education, and curatorial practices to the job of taking the museum to its next phase. The staff also visits other museums on a regular basis to keep up with best practices and standards to ensure the mansion is the best it can be. (Above, courtesy of Glen Campbell; below, courtesy of Trish Mayo.)

250 YEARS

MORRIS-JUMEL MANSION

The year 2015 will usher in a large milestone for the mansion, as becomes 250. Celebrating Manhattan's oldest house will embrace both the new and historic, as events and programs will incorporate the different generations of Shelton, the DAR, and the Morris and Jumel eras while reaching forward to explore the opportunities for the next 250 years. (Courtesy of Matthew Leonenko.)

Six

MEMORIES OF THE PAST
PIECES OF HISTORY

The history of the mansion spans a quarter of a century, and over time, people have wanted to remember their visit, or life, at the house. The museum is lucky enough to still have some of these memories in its collection. The earliest example is this page from architect John E. Pryor's account book, dated January 7, 1769, which makes reference to Roger Morris.

The mansion is fortunate to still hold primary sources from the Morris era, Shown here is a letter that Roger Morris wrote to his wife, Mary Morris, in 1775. The letter looks to date to the approximate time of their departure from Mount Morris back to England due to the outbreak of the American Revolution. Upon their leaving, it was Mary who returned to the mansion once it was occupied by British forces to recover many of the family's possessions. The British troops supposedly allowed Mary to enter in deference to her husband's military rank. There is a rumor that George Washington met Mary Morris prior to her marriage and was her suitor. She was the first in a long line of strong women who would call the mansion home.

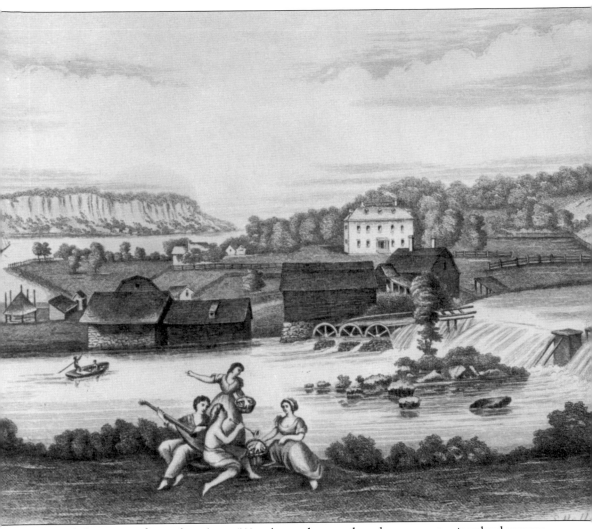

Mary Philipse came from a long line of Dutch merchants, whose home country involved women playing a major role in the running of not only the household, but businesses as well. This engraving, depicting four figures picnicking by a riverside, might have hung in the mansion after Mary's marriage to Roger Morris. The house and farm in the background have been identified as Philipse Manor, which was Mary's childhood home in Tarrytown, New York. It consisted of 54,000 acres of land surrounding the "farm" pictured here. The property also included a manor house in Yonkers. This illustration is signed by S. Hollyer.

This c. 1776 watercolor, by Capt. Thomas Davies of the Royal Artillery, is entitled *A view of the attack against Fort Washington and Rebel Redouts near New York*. After the Morrises abandoned the mansion, the house went through many hands during the Revolutionary War. Paintings such as this one would have been placed in a household during the Revolution to remind the Colonists of their place in the British Empire and, in the case of the attack on Fort Washington, the British army's belief that the uprising would end with the colonies remaining under British rule.

An extremely fragile and important connection to the past is an artifact believed to be Emperor Napoleon Bonaparte's traveling trunk from his Russian campaigns. The trunk, dated to 1812, is thought to have been brought into the mansion by Eliza and Stephen Jumel, who purportedly enjoyed a friendship with the Bonaparte family.

Artifacts are key to telling the story of the mansion. The first person to search the area of the mansion for artifacts to add to the collection was Reginald Bolton. Here, he discovers American officers' Camp Stove near the mansion around 1912. Both he and William Henry Shelton believed in sharing the history of the mansion with early-20th-century visitors in the interpretative style of the day, with items in glass cases and displays.

The mansion itself serves as the most lasting reminder of the history it has witnessed. Although many restorations and repairs have taken place, the "bones" of the house still date to 1765. Here, a cross section of the Holland brick and mortar is visible during a 20th-century conservation project.

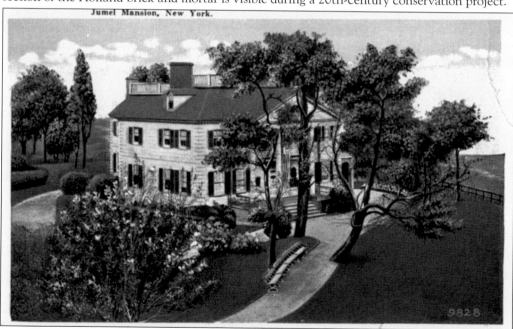

Jumel Mansion, New York.

As the mansion morphed into a museum in the 20th century, visitors wanted a reminder of their experience. Postcards became, and still are, a way for people to keep these memories alive. They also allow historians to see the changing face of the mansion and the interpretive styles throughout the years.

Spring Morning at Mme. Jumel's
the Old Time Washington's Headqu...
orris-Jumel Mansion New Y.rk .i..

Some of the postcards from the early 20th century created a romanticized view of life in the early 19th century. Here, a young lady in a fine Empire-style gown and hat appears to be walking the perimeter fence of the mansion property. Perhaps, she will be meeting with Eliza Jumel in the Parlor for tea. Guests at the time of this postcard wanted to relive the Jumel era, due to its supposed opulence and glamour. The popularity of costumed parties for early generations of the DAR is an example of this reminiscence.

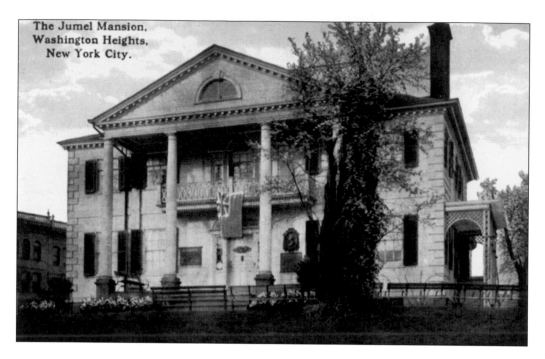

The Jumel Mansion,
Washington Heights,
New York City.

Exterior views of the mansion were the most popular postcard images, as is the case today. Such postcards offer crucial evidence of how the house looked at different times in the last century. In particular, the view from Edgecombe Avenue gives a sense of early industrialization and depicts the height of the house over the rest of the neighborhood. In addition, exterior illustrations often display the various patriotic elements installed by the DAR, including flags and plaques describing the house, as well as a plaque of George Washington in profile (above).

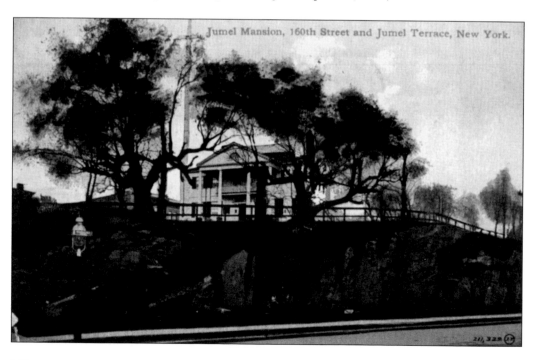

Jumel Mansion, 160th Street and Jumel Terrace, New York.

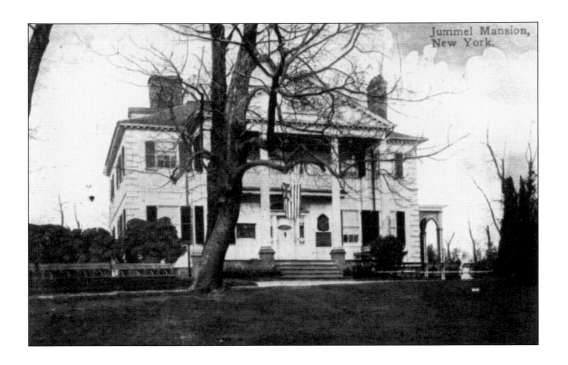

These exterior views show the side lattice walkway that extended along the side of the house toward where the Earle kitchen once stood. The two cannons flanking the front entrance can also be seen on these postcards. The green exterior shutters are still visible, dating these postcards to the very early 20th century. Note that, on the above postcard, the house's name is misspelled as "Jummel."

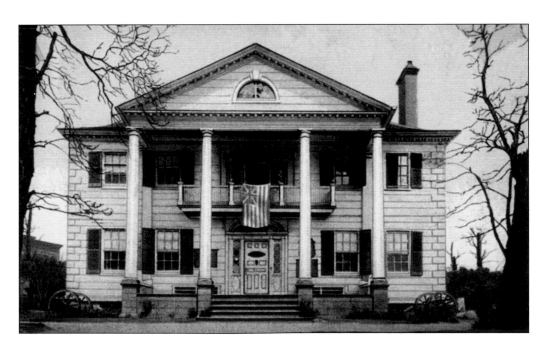

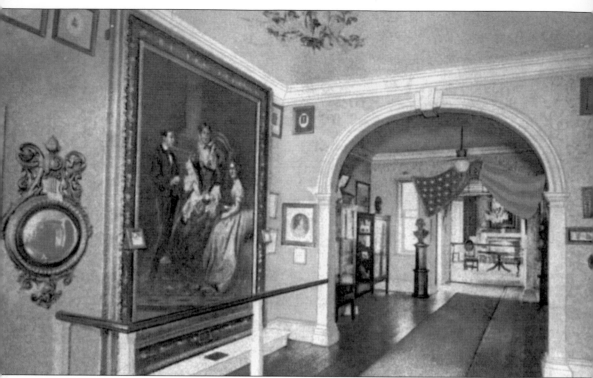

The postcards created during the Shelton era were directly inspired by contemporary photographs. This image is very reminiscent of the photograph of the front hallway with the portrait of Eliza Jumel dominating the scene (see page 38). Interestingly though, the intent was not to create postcards from the actual photographs themselves, but instead to create drawings of the different interior rooms. This idea, perhaps advocated by the DAR or by Shelton, allowed the images to be viewed as mini-artworks, as opposed to the later "picture postcard" style.

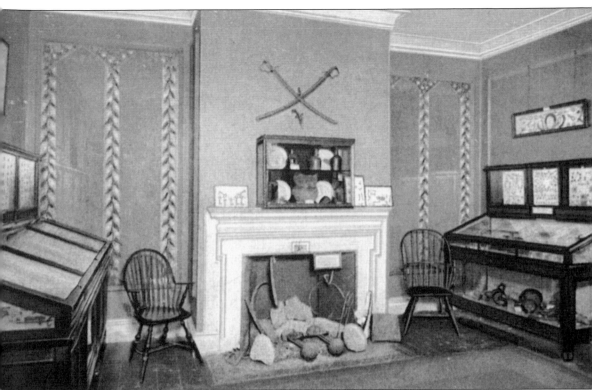

This is the "artillery" room, designed by William Henry Shelton and Reginald Bolton. Included here are cases of Revolutionary War artifacts that Bolton had found on the grounds of the mansion during his archeological digs. The style of the cases may seem old-fashioned to viewers today, but this classic cabinet-of-curiosities method of display was well regarded in the early part of the 20th century. Many of these artifacts are still part of the mansion's collection and are used as teaching tools for school programs today.

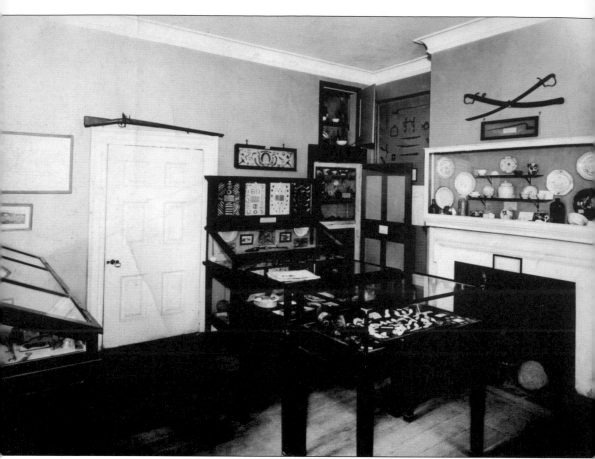

The upper floor of the mansion in the Shelton era continued the display-case style of interpretation. Among the prints on the walls are images of George Washington and the Founding Fathers. Others seem to be scenes from Revolutionary War battles. In the cases are various artifacts, and also seen are guns, swords, and other military memorabilia. The long shot looking through the hallway into George Washington's bedchamber gives a heightened sense of space and theme.

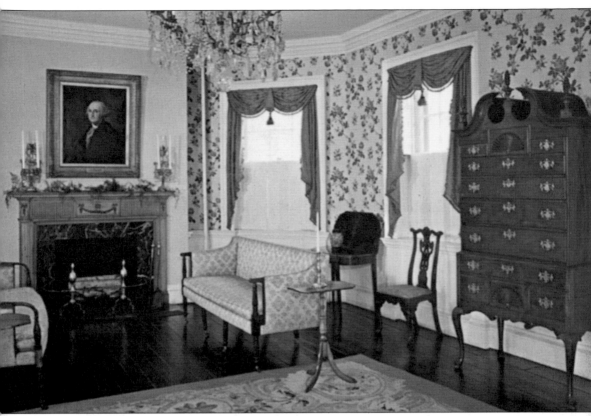

This postcard of George Washington's bedchamber, with a later mid-century interpretation, gives an idea of the push and pull of historically "accurate" furnishings versus what the curator, director, and donors of a museum feel to be correct. Since Washington used the mansion as his headquarters during the Battle of Harlem Heights, the late-18th-century furnishings pictured here would not have been present during his stay. However, they do lend themselves to the Colonial Revivalism style popular with the DAR during the majority of its tenure at the mansion. The fireplace mantle pictured here is no longer at the mansion; each mantle was replaced with a plain, Federalist-style example in the middle of the 20th century.

The second-floor hallway carried on the patriotic theme by including a Revolutionary War flag and prints in the theme of the Founding Fathers.

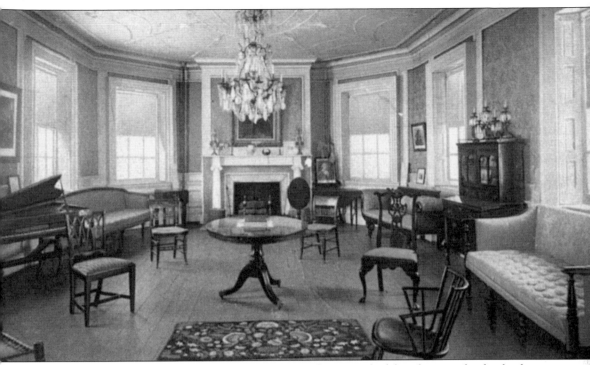

The Octagonal Drawing Room, similar to George Washington's bedchamber, involved a display that included a wide variety of furniture styles and designs. The plaster ceiling, installed by the Earle family, is visible here. Unfortunately, during renovations in the 20th century, it was covered over and is no longer visible to visitors. Of interest in this postcard is the lived-in feel of the room. Despite being curated to resemble a certain era, notwithstanding the different style furnishings, the space looks as though it could be used as a contemporary living room. This juxtaposition is central to the ideas of the DAR, which wanted a historic space, but one in which people felt welcome as well.

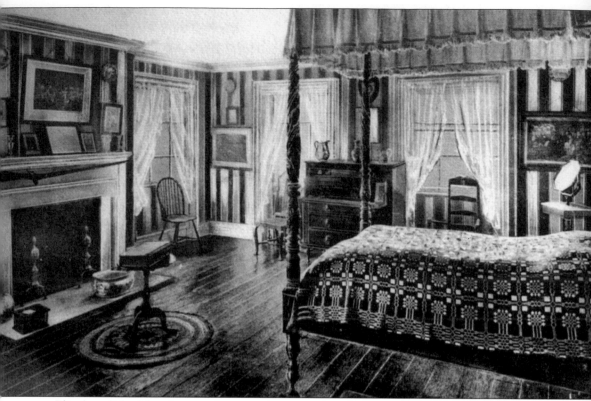

Eliza Jumel's bedchamber was the room that seemed to alter its interpretation the most often—and to have the most spinning wheels at any given moment. This depiction offers a bit of the weathered Victorian style that would have likely been present in the later part of Eliza's life.

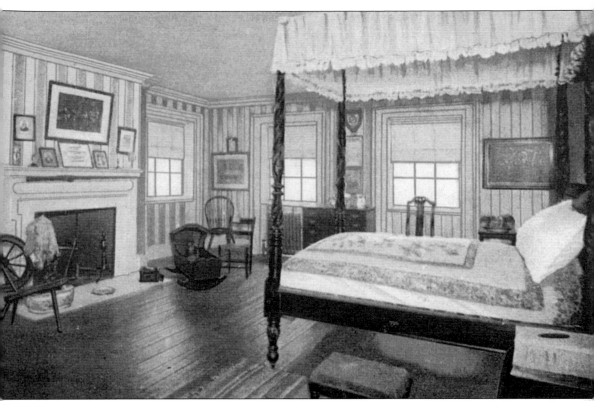

Different postcards of Eliza's room demonstrate that similar items can be placed in the same space but offer a completely different interpretation. Simple changes in wallpaper and bed coverings can make a huge difference in how a visitor views the space and how the room is perceived.

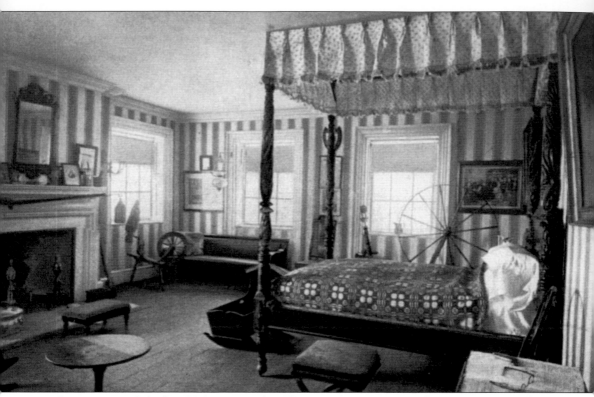

It was not until the late 20th century that Eliza's room was set up in the proper way, emphasizing the high style and grandeur of the mid-19th century. Throughout the DAR era, the room would still have a Colonial Revival feel, with dashes of the accurate portrayal of Eliza's era.

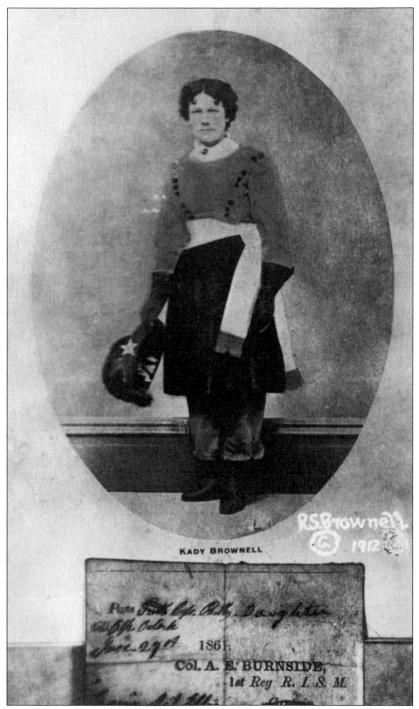

KADY BROWNELL

Pass ... lift. ... Daughter
... Clerk
June 29 1861.
Col. A. E. BURNSIDE,
1st Reg R. I. S. M.

The caretakers for the mansion have always been the first line of defense and also its greatest supporters. The first caretaker, Kady Brownell, is pictured here at age 18 in 1861. Brownell actively fought in the Civil War as a Union soldier. She is seen here in her full Union uniform. After the war, she became caretaker of the mansion and the park under the direction of the DAR and William Henry Shelton.

DRAWING ROOM
Roger Morris-Jumel Mansion
West 160th Street and Edgecombe Avenue
New York City
Built in 1765

The Washington Headquarters Asso-
ciation cordially invites you to
hear Dr. Samuel Engle Burr, Jr.,
President General of The Aaron
Burr Association, speak on "Aaron
Burr at the Morris–Jumel Mansion,"
Sunday, September 21, at 2:00 p.m
at the Mansion. For reservations,
please call WA 3 - 8008.

Members: free
Guests: $2.50

Published by Washington Headquarters Association,
Founded by Daughters of the American Revolution

Photography by LOUIS H. FROHMAN, Bronxville, N.Y.

ICS-71741-

POST CARD

Address

PLACE
STAMP
HERE

The fun thing about discovering the various postcards in the mansion's collection is looking over the writing on the reverse sides. This postcard includes an invitation for a lecture given by Dr. Samuel Engle Burr Jr. on Aaron Burr's life at the mansion. The mansion still has a relationship with the Aaron Burr Association, annually holding events about Burr. The house has become the unofficial center for Burr-related events in New York City.

Another famous person to visit the mansion was Gore Vidal, who held a reception at the museum for the debut of his novel *Burr* in 1973.

ROGER MORRIS-JUMEL MANSION
Washington Headquarters 1776
West 160th Street and Edgecombe Avenue
New York City

Published by The Washington Headquarters Association

Color by DEXTER COLOR NEW YORK, Inc., 274 Madison Ave., N. Y.

N. Y. News Color Photographer

24130-B

POST CARD

Kayo Love —
 This comes from
my collection of
when-I-was-young
postcards (not quite
antiques), to tell you
how much I enjoyed
The Members' Luncheon
with you. 1983's off
to a better start Than
some years!
 Please give Paul our love
hope you find The right
spot soon for Mr. P xxx Abby

Mrs. Paul Parker
1170 Fifth Avenue
New York
 New York
 10029

The last word in a book about the history of the mansion needs to include Kayo Parker, seen in earlier photographs during the visit of Queen Elizabeth II. Kathleen Parker was a longtime trustee and friend of the museum. She would champion everything from Baroque concerts to garden parties, and she always wanted what was best for the mansion. This 1983 postcard, sent by Abby, a member and friend, encapsulates how dedicated Kayo was not only to the physical structure of the mansion, but to the people who visited. Kayo, who unfortunately passed away in 2013, and other women have worked hard to preserve the mansion for future generations to enjoy.

BIBLIOGRAPHY

Burrows, Edwin G. *Gotham: A History of New York City to 1898*. New York: Oxford University Press, 2000.

Davis, Kenneth C. *Don't Know Much About History: Everything You Need to Know About American History but Never Learned*. New York: Harper Collins Publishing, 2003.

Deschamps, Madeleine. *Empire*. New York: Abbeville Press, 1994.

Ellis, Joseph J. *His Excellency: George Washington*. New York: Random House, 2004.

Homberger, Eric. *The Historical Atlas of New York City: A Visual Celebration of 400 Years of New York City's History*. New York: Holt Paperbacks, 2005.

Lankevich, George. *New York City: A Short History*. New York: NYU Press, 2002.

Zimmerman, Jean. *The Women of the House: How a Colonial She-Merchant Built a Mansion, a Fortune, and a Dynasty*. Florida: Harvest Books, 2007.

DISCOVER THOUSANDS OF LOCAL HISTORY BOOKS
FEATURING MILLIONS OF VINTAGE IMAGES

Arcadia Publishing, the leading local history publisher in the United States, is committed to making history accessible and meaningful through publishing books that celebrate and preserve the heritage of America's people and places.

Find more books like this at
www.arcadiapublishing.com

Search for your hometown history, your old stomping grounds, and even your favorite sports team.

Consistent with our mission to preserve history on a local level, this book was printed in South Carolina on American-made paper and manufactured entirely in the United States. Products carrying the accredited Forest Stewardship Council (FSC) label are printed on 100 percent FSC-certified paper.

MADE IN THE USA